RAPHAEL

The Stanza della Segnatura

Raphael

The Stanza della Segnatura

James Beck

GEORGE BRAZILLER NEW YORK

ACKNOWLEDGEMENTS

I would like to thank Jodi Cranston for reading this manuscript and for her suggestions and corrections. My friend Michael Daley was helpful especially in understanding fresco technique. I would like to mention also Gordon Bloom and Andrew Ladis, both of whom have read parts of the manuscript, and to thank Adrienne Baxter, my editor.

—*James Beck*

Published in 1993 by George Braziller, Inc.
Texts copyright © George Braziller, Inc.
Illustrations (except where noted) © Scala Archives, New York

For information, please address the publisher:
George Braziller, Inc.
60 Madison Avenue
New York, New York 10010

Library of Congress Cataloging-in-Publication Data

Beck, James H.
 Raphael: The Stanza della Segnatura, Rome/James Beck.
 p. cm. (The Great Fresco Cycles of the Renaissance)
 Includes bibliographical references and glossary.
 ISBN 0-8076-1314-2
 1. Raphael, 1483-1520—Criticism and interpretation. 2. Mural painting and decoration,
Renaissance—Vatican City. 3. Stanza della Segnatura (Vatican Palace, Vatican City) I. Title II. Series.
 ND623.R2B363 1993
 759.5—dc20 93-13059
 CIP

Designed by Lundquist Design, New York
Printed by Arti Grafiche Motta, Arese, Italy

CONTENTS

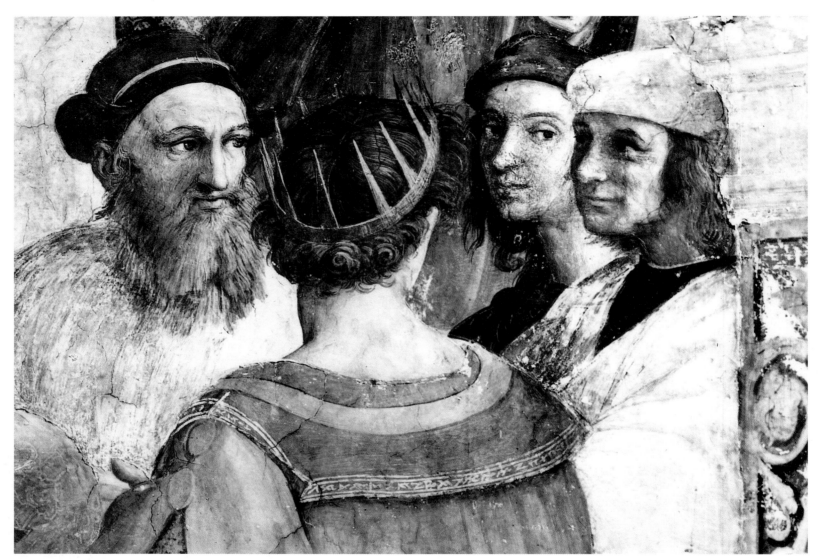

Raphael, detail, the *School of Athens,* from left to right: Zoroaster, Ptolemy, Raphael, Perugino (?) (see pl. 32).

THE STANZA DELLA SEGNATURA

The pictorial masterpieces of Raphael and Michelangelo present themselves hardly more than fifty yards apart from one another within the labyrinthine Vatican Palace: the Stanza della Segnatura, sometimes called the Camera della Segnatura, and the Sistine Chapel ceiling. Together they established a standard of quality and invention that was to become the gauge of the finest achievements for the next four hundred years of European painting. These paintings were produced simultaneously and in the same technique, fresco. Most specialists consider the paintings in the Segnatura as the finest of the period and, what is more, they have come down to us, all things considered, in very acceptable condition. The conventional bias is that here the cultural revolution known as the Renaissance, which was first signaled in the pictorial arts by Giotto in the fourteenth century and then elaborated upon in the next century by Masaccio, Piero della Francesca, and Signorelli, achieved its finest hour.

Like any complex historical moment, the Renaissance cannot be simply defined, but one can say that in contrast to the previous one, the Middle Ages, a greater emphasis was placed on the role of man as the principal measure of all things. The Renaissance was also a time of explorations and expansion of the world as the Europeans had known it. Another principal ingredient was, of course, a rebirth, as the word actually signifies, or revival of Antiquity in thought as well as in the arts. Manuscripts of Greek and Roman writers were sought, copied, translated, and prized, just as Greek and Rome sculptures became the centerpieces of collections, and their forms gave rise to new interpretation for contemporary artists. Hence the Renaissance was both a period of general expansion of horizons as well as a conscious revival of past glories and achievements of the ancients. These strands are extremely well represented in the Segnatura frescoes by Raphael who, in fact, is able quite remarkably to harmonize in single, credible settings the old and the modern.

A venerable pictorial mode for decorating walls and one that had an extensive flowering in Italy during the fourteenth, fifteenth, and sixteenth centuries, fresco is basically painting on a masonry support especially prepared for the purpose. A thin layer of rough plaster, a mix of lime and sand called *arriccio,* is applied to the wall. A sketch for the painting, the sinopia, was then often drawn directly onto the wall as a guideline for the artist. This practice was common during the fourteenth and fifteenth centuries, but came to be replaced in part by the use of drawings on paper or cloth, cartoons, with which an artist could transfer a drawing directly to the plastered wall. Then another thin, but finer grained film of plaster, the *intonaco,* is applied section by section corresponding to a single day's work, known as a *giornata,* covering the sinopia or cartoon drawing in the process.

The artist paints with mainly earth colors on this still wet layer. In its theoretically purest form, *buon* fresco, pigments are mixed only with water and, by some miracle of chemistry, the colors become locked into the surface of the plaster as they dry, becoming physically part of the wall. Indeed, its crystalline surface is similar to that of marble, making for a highly durable surface, when not attacked by pollution or by salts brought on by humidity. Commonly the artist, after painting the wet plaster, finds it necessary or desirable, due to the composition of certain colors, to harmonize and even correct certain aspects, to make adjustments, which are executed by means of *secco*, or dry, techniques over the hardened layer. Here pigments are tempered with egg, glue, or gums and are laid over the pure fresco surface. Both approaches were used widely, and by Raphael in the Stanza della Segnatura and by Michelangelo in the Sistine Chapel.

Raphael, whose name is Raffaello Sanzio or Santi, painted this papal chamber, the Stanza della Segnatura, precisely at the same time that Michelangelo executed the ceiling of the Sistine Chapel. The two projects, which of course differ vastly in size and subject matter, must have instilled an air of competition between the two artists, despite a gap in their ages. Raphael was born in 1483 in Urbino, a hill town near the Adriatic coast; Michelangelo, a Florentine, was born in the countryside eight years earlier.

Working for the same patron, Pope Julius II, Raphael was given ample latitude to demonstrate his gifts in the Stanza della Segnatura and subsequently in three other papal rooms, collectively referred to as either Raphael's *stanze* or *camere*. Of these four contiguous rooms that Raphael embellished, now part of the Vatican Museums, we are specifically interested here in one of the smallest, the Segnatura, which was the first one Raphael was ordered to paint. He probably became involved in the commission in 1508, the same year Michelangelo began to work on the Sistine ceiling. The others are the Camera dell' Incendio (Fire in the Borgo), the Camera d'Eliodoro (Heliodorus) (see page 10), and the Camera di Constantino (Constantine), the largest (see opposite).

To return briefly to the discourse regarding an interplay with Michelangelo's overwhelming Old Testament cycle, Raphael actually depicted one of the same scenes, the *Temptation and Fall of Adam and Eve,* offering a fascinating opportunity to compare the two masters, at this first phase in Raphael's Roman period (see pages 32-33). But more important still, we have with the two cycles an opportunity to set virtually side by side their modes of depicting the human figure at the same, extremely potent historical moment.

Raphael and Michelangelo pertained to different factions among the artists active in Rome in the early sixteenth century. The Florentines were headed by the scuptor-architect Giuliano da San Gallo and the painter-sculptor Michelangelo; while the competition was managed, as it were, by another architect, Donato Bramante, who came from the same hill town as Raphael, namely Urbino, to which Julius II also had close family ties. Consequently, not only was there a fairly intense rivalry between the factions for lucrative architectural commissions (after all, Bramante had the enormous and prestigious task of erecting a new St. Peter's basilica while his contemporary da San Gallo was left with lesser assignments), but Michelangelo and Raphael were squared off vying with one another for the crown as the pope's favorite painter.

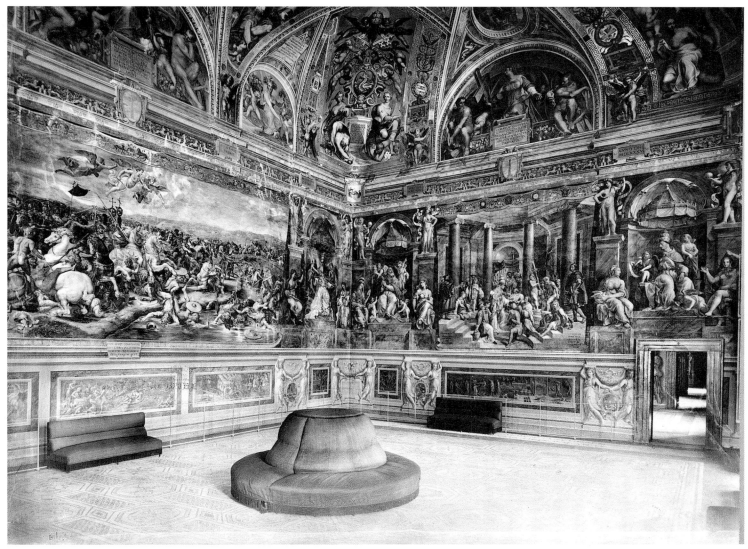

Raphael and assistants, the Camera di Constantino, 1518-24, fresco, Vatican, Rome

Raphael, *The Expulsion of Heliodorus* from the Camera d'Eliodoro, 1511-12, fresco, Vatican, Rome. The bearded figure seated on the second tier at the far left of the composition is a portrait of Julius II, as may well be the bearded figure kneeling at the center of the composition.

Michelangelo, to be sure, regularly claimed that painting was not his art and would have dropped the Sistine project had he been able to do so gracefully, in order to return to sculpting the statues of the Pope's massive tomb. Undoubtedly, however, Michelangelo was looking over his shoulder, so to speak, to keep a keen eye on precisely what his well sponsored young rival, Raphael, was generating. In retrospect Michelangelo asserted that Raphael learned everything he knew about painting from him; surely an unfair avowal, perhaps intended as a rhetorical exaggeration. Still, the claim has brought the attention of art scholars to the issue of interdependence between the two leading artists of the fully mature phase of the Renaissance, often referred to as the "High Renaissance." Ideas in the form of specific poses and figural types that Raphael may have borrowed from the older man, but also a more deeply rooted approach to the human body, have been pinpointed. On the other hand, Raphael's presence may have affected the later stages of Michelangelo's Sistine ceiling by a certain softening of his approach.

Before entering into the merits of such exchanges and to more deeply evaluate Raphael's remarkable and unrivalled contribution, it seems appropriate to offer a biographical sketch of Raphael, then to consider at least briefly the personality and character of Pope Julius II, the patron of the Segnatura, before finally turning to the room, its unrivaled frescoes, and their style and meaning.

Raphael, son of the painter, courtier, and poet Giovanni Santi of Urbino, was orphaned at the age of eleven, when he was raised by uncles. Even before his father died, he seems to have been destined to become a painter. Following his earliest instruction from his father, the precocious lad was subsequently guided by several masters active in Urbino, where there was a distinguished artistic tradition. Important artists worked there or in the area in the past, like Piero della Francesca from Borgo San Sepolcro, Luca Signorelli from Cortona, and Francesco di Giorgio Martini from Siena, and left a legacy that provided the budding young painter with an artistic heritage of the highest level.

Raphael became associated with Pietro Perugino, arguably the most renowned painter in Italy during the concluding decades of the fifteenth century (along with Leonardo da Vinci, who had been far away in Milan the better part of 20 years, and Giovanni Bellini in Venice), in 1501, when he was about eighteen. Perugino, it should be recalled, had wide experience in much of Italy, and in the early 1480s was involved with frescoes in the zone beneath the ceiling of the Sistine Chapel in Rome, along with such prominent masters as Ghirlandaio and Botticelli. Perugino, although he travelled widely, maintained his position as his native Umbria's dominant painter.

Without question Raphael had been placed in most excellent hands. His guardians, we must assume, were not satisfied that he should become a limited, provincial master like his father, but sought for him a career as a painter of universal scope and reputation. Tradition, which is confirmed by a stylistic examination of his early altarpieces, records that Raphael, before he turned twenty, had mastered Perugino's manner to such an extent that it was virtually impossible to distinguish the works of the pupil from that of the master. Although this statement is somewhat extreme, the evidence in the form of early paintings and drawings points clearly to the conclusion that Raphael was an ideal student and an exceedingly rapid learner. Raphael's first

major commission, dating to 1501, the San Niccolo da Tolentino Altarpiece (Naples, Bergamo, Paris), which has survived only in fragments, can be understood by a number of extraordinary preparatory drawings produced for it. While approaching Perugino's formal language, Raphael still retains the flavor of his more provincial training. Already dating back to his first altarpiece, we have a substantial number of drawings and studies by Raphael that document not only his evolution as an artist but his procedure, from idea to final painting. This situation is especially true for many of the frescoes in the Segnatura.

The masterpiece of his Peruginesque phase is the *Marriage of the Virgin* (Milan, Brera), dated 1504, which he created for a church in Città di Castello (see right). In it he brought the manner of his teacher to a final state of perfection. The elegant elongated figures reveal themselves with small oval heads and petite features, rendered in attractive and even distinctive color. Besides, Raphael was able to design with impressive conviction the contemporary temple in the middle ground and to locate the scene within a luminous landscape.

Understandably after a period of time, perhaps three years, either Raphael himself, his uncles, or all together in concert thought it desirable for the young man to move beyond the manner of Perugino, whose delightful, impeccably refined figures lacked physical conviction and authority. Indeed, following the *Marriage of the Virgin,* a change was a virtual imperative, for it seemed impossible to proceed further within Perugino's orientation without becoming hollow and redundant. Thus, toward the end of 1504, Raphael was sent to Florence to perfect his art and especially to "learn," that is to become acquainted with the new, alternative manner then being formulated by the

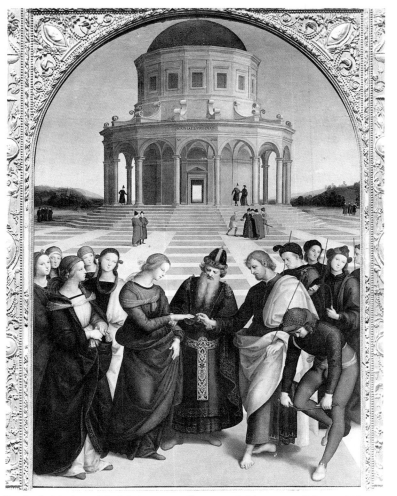

Raphael, *Marriage of the Virgin,* 1504, oil on wood, Pinacoteca di Brera, Milan

already mythic Leonardo da Vinci, who had returned home from a long stay in North Italy. Raphael was already a proven artist with significant pictures to his credit, but in Florence he sought to expand his artistic horizons and enrich his vocabulary.

Michelangelo was present in Florence too, in those very years, emerging as a leading artistic force who could even challenge the reputation of Leonardo. Only a few months before Raphael's arrival, he completed the marble *David,* immediately heralded as the most marvellous statue made since Roman times. Raphael himself, as proof of his desire to apprehend and participate in the newly delineated approach to the human figure and particularly the nude, actually made a drawing of Michelangelo's huge marble.

As far as we can gather from documentary evidence, Raphael came to Florence to learn, and in so doing he first began to study not merely the new giants of art, Leonardo and Michelangelo, but those masters and traditions that gave rise to them. Specifically, he seemed to want to recapture the art in Florence as it unfolded toward the beginning of the fifteenth century, and so studied the works of painters like Masaccio and Filippo Lippi and of sculptors including Donatello and Luca della Robbia. In the span of less than four years, from late 1504 until mid-1508 (when he was called to Rome by Julius II), Raphael retraced the innovations that defined Florentine art, old and new, and so armed, he burst upon the Roman art scene.

Raphael, notwithstanding the age differences, was confident that he was a worthy equal of not only Michelangelo, but also the much older Leonardo da Vinci, whose vision served him decisively as he was liberating himself from the more restrictive idiom of his previous artistic mentors. Raphael had made it

known that he was prepared to participate in the murals for the vast public room in Florence's Palazzo Signoria (later dubbed the Palazzo Vecchio) that had been allotted to these two proven artists. As further evidence of self-confidence, he even expressed a desire to paint the second half of the Sistine ceiling, following a pause midway in Michelangelo's work, an idea that infuriated the Florentine.

The most thorough and authoritative biography of Raphael, as with so many artists of the period, is that composed by Giorgio Vasari (2nd ed., 1568), in which Raphael is portrayed as a most gracious and handsome person. Vasari opens his life of the artist with the following description:

> The liberality with which Heaven now and again unites in one person the inexhaustible riches of its treasures and all those graces and rare gifts which are usually shared among many over a long period is seen in Raphael Sanzio of Urbino, who was as excellent as gracious, and endowed with a natural modesty and goodness sometimes seen in those who possess to an unusual degree a humane and gentle nature adorned with affability and good-fellowship, and he always showed himself sweet and pleasant with persons of every degree and in all circumstances. Thus Nature created Michelagnolo Buonarroti to excel and conquer in art, but Raphael to excel in art and in manners also.

He had, according to the biographer, a modest nature, full of good will and affability, and on that score much more so than Michelangelo. With respect to Raphael's nature and character (and perhaps with Michelangelo's too), Vasari as well as the artists' contemporaries appear to have associated the images these men created, that is, their painted figures, with their actual personalities and

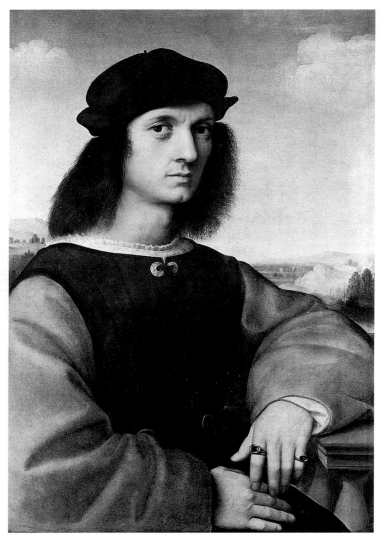

Raphael, *Portrait of Angelo Doni,* ca. 1505, oil on wood,
Palazzo Pitti, Florence

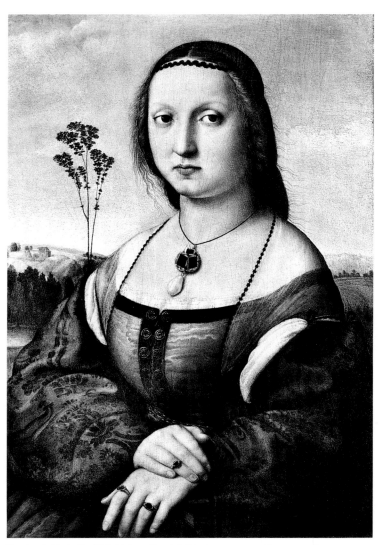

Raphael, *Portrait of Maddalena Strozzi Doni,* ca. 1505, oil on wood,
Palazzo Pitti, Florence

even their appearances, like several in the Segnatura frescoes. Raphael was described as without those vices that are commonly found among artists, including a touch of madness or uncontrollable wildness. Instead, still according to Vasari, the rarest virtues of the soul were resplendent in persons such as Raphael, who are "not mere men but, if it is permitted to say so, mortal gods."

As has already been indicated, Raphael appears to have studied locally in Urbino with his father, Giovanni Santi's, collaborators, and then he was sent to Perugia to study with Pietro Perugino. Following a period with the Umbrian artist, he achieved a certain local fame although hardly twenty-one years of age. By the time Raphael went to Florence, he had the powerful backing of the Ducal family in his native Urbino. Indeed, he was presented to the Florentines with a letter from Giovanna da Montefeltro, the sister-in-law of the reigning pope, Julius II (della Rovere).

In Florence Raphael managed to obtain many, mainly small commissions, soon achieving a reputation for his devotional paintings of the Madonna and Child for private palaces and family chapels. Raphael's first direct confrontation with Michelangelo's art must have occurred in Florence, where they shared a wealthy merchant patron, Angelo Doni. Raphael executed a pair of portraits of Angelo Doni and wife (see left), while around the same time (ca. 1504-05), Michelangelo produced his *Doni Tondo,* representing the Holy Family (see right). During the Florentine years, Raphael maintained connections with his home city of Urbino and probably travelled frequently back and forth over the Apennines. In Urbino, he painted a noble woman, a picture usually called *La Muta* (National Museum, Urbino). Portraits such as this one provided Raphael with an opportunity to distinguish

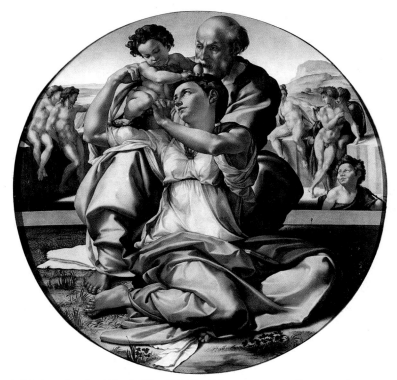

Michelangelo, *Doni Tondo (The Holy Family),* ca. 1504-05, oil on wood, Uffizi, Florence

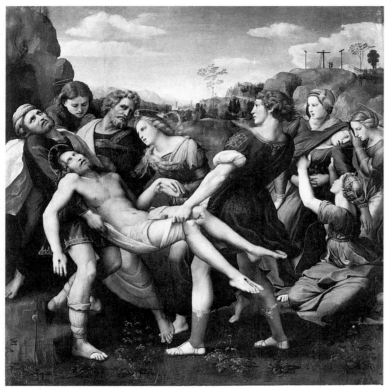

Raphael, *The Entombment of Christ*, 1507, oil on wood, Galleria Borghese, Rome

himself in an area unexplored by Michelangelo. Raphael's skill with likeness and his penetrating ability to capture the character of his subjects find expression in his frescoes as well, especially those in the Segnatura.

The most influential and complex painting dating from his Florentine years, late 1504 to mid-1508, was the *Entombment of Christ,* which was commissioned by a leading member of the ruling family of Perugia (Galleria Borghese, Rome, see left). Here we see a dramatic shift away from the almost exclusively Peruginesque Raphael to a more cosmopolitan artist who was conscious of the most progressive innovations then unfolding in Italy, including knowledge of the newest developments in Venice as represented by Giovanni Bellini, Giorgione, and Titian.

A crucial challenge came when he was introduced to the papal court, presumably by Bramante, who besides being a countryman is thought to have been a distant relative. In Rome, due to his personal beauty and his gracious character but also his remarkable talent, Raphael became extremely successful in obtaining influential commissions for the remainder of his life, which was short by any standard, and especially in comparison to Michelangelo's. Soon after his arrival in 1508 until his death twelve years later, Raphael became the dominant painter in Rome, outshining even Michelangelo, who after finishing the Sistine ceiling (1512), devoted most of his energy to sculpture during the next three decades. It is generally assumed that Raphael began work, at least in a planning stage, on the Stanza della Segnatura by mid-1508 and finished the decoration there in 1511. He then went ahead and painted the other three rooms nearby during the subsequent decade.

In Rome, where he was given diverse prestigious assign-

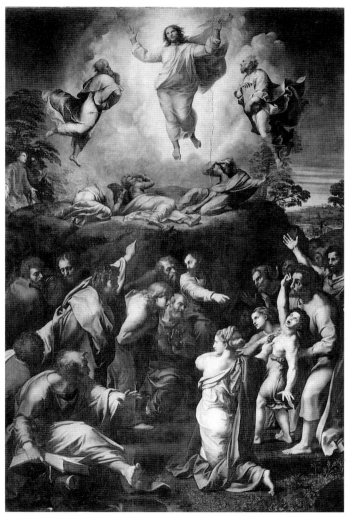

Raphael, *The Transfiguration,* 1519-20, oil on wood,
Vatican Museum, Rome

ments, he also went on to expand his interests to include archi-
tecture and the study and preservation of Roman Antiquities.
Naturally he continued to paint for the most powerful patrons in
Italy, including Pope Leo X and other members of the Medici
family, as well as wealthy patrons like the Chigi. Among his
ambitious works were a series of painted cartoons for weavers of
vast tapestries that were designed to be displayed in the Sistine
Chapel and an extensive altarpiece depicting the Transfiguration
(Rome, Vatican Museums, see left), commissioned by Cardinal
Giulio de' Medici, later Pope Clement VII, which was designed
for a royal French destination, but was never dispatched. The
painting was put on public display for Raphael's funeral held in
the Roman Pantheon. Raphael died at the age of 37, presumably
on the same feast day as his birthday, Good Friday, in 1520, but
his contemporaries mistook his age to have been 33; that is, the
age of Christ at His death.

Julius II (Giuliano della Rovere), the patron of the Stanza
della Segnatura, was one of the Renaissance's most dynamic
popes. Born in the town of Savona on the Tyrrhenian coast
between Pisa and Genova, his ecclesiastical career received impe-
tus from his uncle Pope Sixtus IV. Giuliano, who became pope
in 1503, sought to embellish the papal residence at the Vatican
and began several projects ex novo. Apparently Julius inherited
his interest in architecture and urban planning from his uncle,
Sixtus IV, whose contributions include the Hospital of Santo
Spirito and the Sistine Chapel. But Julius had his own aspirations
for the Vatican and appointed Donato Bramante from Urbino as
his chief architect to carry out his most radical project, in addi-
tion to his gigantic tomb. The old, early Christian Basilica of St.
Peter's was torn down and a new one was erected in its stead, a

task of such complexity and expense that it took more than a hundred and fifty years to complete. The destruction of the venerable 1,000-year-old building was not always interpreted positively by contemporaries, including Michelangelo. Indeed, the historian M. Creighton harshly observed a century ago that: "No more wanton or barbarous act of destruction was ever deliberately committed…His [Julius's] boundless vanity and self-assertion was accompanied by insolence to the past.…" The new church was founded by the pope on 18 April 1506, two years before Raphael settled in Rome.

Julius II was as much a politician and military leader as he was a cleric. He sought to keep the Borgia faction under control, to achieve a balance of power in Italy between the various conflicting city-states, and to hold in check the territorial aspirations of the French and the Holy Roman Emperor. Simultaneously, he sought to expand the papal state and, in this regard, his most concentrated efforts were directed toward obtaining for the papacy control of Bologna, a wealthy city-state in the middle of the Italian peninsula. Implacable in battle, he led the papal army with passion and was considered by his contemporaries as a particularly dynamic personality, often described as "terribile," which meant that he had a forceful and fiery nature. Raphael actually portrayed the Pope various times, including what amounts to an official portrait (versions in Florence [Pitti and Uffizi] and London [National Gallery, see right]), presumably close to his death on 2 February 1513, and his likeness may be found several times in the *stanze,* including a representation in Segnatura, in the guise of Pope Gregory IX, on the wall of the room that treats the concept of Justice.

Julius, who was unwilling to use the quarters that had been

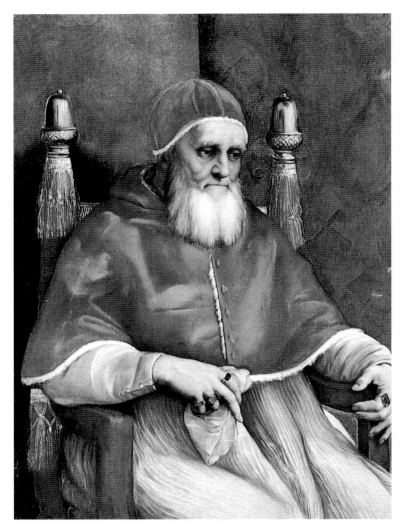

Raphael, *Portrait of Pope Julius II,* 1511-12, oil on wood, National Gallery, London

prepared by his predecessor, Pope Alexander VI (Borgia), wished to design his own, which would be created according to his own specifications. This is how the pictorial programs of the *stanze* were conceived, and when considering specifically the Segnatura, we must contantly be reminded that the pope's presence, his personality, and his desires are paramount ingredients for any sensible reading of the frescoes.

The name Stanza della Segnatura does not appear to be original with the decoration but was attached to it at a slightly later but unspecified date, when the room functioned as a Tribunal of the Curia presided over by the pope. At the time Raphael painted the frescoes, however, the room was destined to serve as Julius's private library. Its intended use as a library offers another key to a cohesive appreciation of the intricate program offered by Raphael.

In the chronology of the murals' execution, which began as it almost always does in the case of fresco at the top and moved downward, the ceiling was done first. Here the attentive viewer is provided insight into the thematic structure of the entire cycle, at least in its broad outlines.

The ceiling, a vaulted structure, was not only painted first but was probably conceived to be seen first by the spectator entering the room, before, that is, moving his glance down to the frescoes on the four walls (pl. 2). There is some reason to believe that another painter called Il Sodoma, previously active in Siena, had been given some responsibility over the room and that he began to paint on the ceiling before Raphael was called in. The common assessment among historians is that Raphael, once in charge, eliminated nearly all of the work Sodoma is presumed to have done there, except decorative borders and some tiny imitation marble panels.

The ceiling plan is calibrated by an intricate constellation of elaborate tromp l'oeil frames into which are set distinct depictions. The Papal arms with the keys and tiara, actually painted stucco, which is set apart by a wide, painted frame, are in the central compartment, which, in turn, is octagonal in shape. Within the frame we find winged, nude putti in sharp foreshortenings frolicking about in diverse poses. This segment is uniquely given a blue background, indicating that open sky is implied here. A certain playfulness in this element recalls the ceiling of another famous room in art, the Camera degli Sposi in the Ducal Palace of Mantua, painted a generation earlier by Andrea Mantegna, Giovanni Santi's favorite painter (see page 30).

The central octagon seems to have given rise to the scheme of the entire ceiling. The eight main scenes are each related to one of the sides, alternating between circular and rectangular elements. Furthermore, there are tiny depictions, four in imitation of Antique marble reliefs (perhaps executed by Sodoma) and four related to mosaic, again reinforcing the number eight.

The four axial sides of the octagon abut four large circular frames, or tondi, each of which presents a seated young woman. We know from inscriptions and from the account in Vasari that they are Justice, Theology, Poetry, and Philosophy. These personifications encapsulate the themes of the large frescoes beneath, thus offering resolute cohesion to the pictorial program. These 'tondi,' or roundels, are connected in meaning with the rectangular scenes and must virtually be read in an overall circular pattern, either clockwise or counterclockwise, in pairs. For example, the *Temptation and Fall of Adam and Eve* is connected with *Theology,* next to it; *Apollo and the Punishment of Marsyas* with *Poetry; Astrology Putting the Stars in the Appointed Place* (?),

also known as the *"Prime Mover,"* with *Philosophy;* and the *Judgment of Solomon* with *Justice.* Intersections such as these raise a basic question about the program, and many Renaissance programs, for that matter. Did the artist, in this case Raphael, conceive the themes on his own or was there a humanist or theologian at the court who put the outlines at his disposal? As will be demonstrated shortly, the subjects are treated with considerable learning, which may preclude the possibility that an unassisted Raphael was the originator. Judging from his letters and his poetry Raphael did not have a profound formal education. Thus we must assume the presence of an adviser or programer, and if it seems unlikely that the pope himself produced the program in detail, he might well have laid out basic ideas and then turned to a theologian/humanist in his court, quite possibly a Franciscan like himself. Cardinal Francesco Alidosi, a papal intimate who probably supplied that outline of the program for the Sistine ceiling, may also have contributed to the plan of the Segnatura. But whoever it was, since the style and content are so brilliantly integrated, Raphael must have been an effective collaborator.

From the outset no strict divisions appear to have been imposed, for we have two Old Testament scenes, the *Fall* and the *Judgment of Solomon,* and an incident from classical mythology, while *Astrology,* or the *Prime Mover,* is of uncertain origin, but does occur in Tarot cards popular in the Renaissance.

In general terms, Raphael's style on the ceiling still reveals his intense Florentine experience. The impact of Leonardo on the young artist seems one of his most meaningful stylistic preparations at this stage. For example, the figural type of the heavy-limbed Eve in the *Temptation,* with its rather tight contrapposto, reveals a clear commentary on Leonardo's language as Raphael had recently experienced it. But Raphael had also brought with him to Rome orientations that either predated the Florentine stay or occurred simultaneously during those years. There is, for example, good reason to believe that Raphael, while more or less based in Florence from late 1504 until mid-1508, made at least one trip to northern Italy, to Bologna, Mantua, and even Venice, and as noted the ceiling in particular reflects knowledge and admiration for Andrea Mantegna's solutions to the challenges of ceiling decoration.

Moving down to the arcuated walls, the first of the four large frescoes produced was the *Dispute over the Sacrament* (see pl. 11). The titles as commonly applied to all of the frescoes in the Segnatura are not necessarily or even likely those Raphael may have had in mind but are, instead, ones that became habitual over time. The *Disputa,* for example, represents not a "dispute" at all but an explication or exaltation of the host. At least from the records we possess, and there is only limited evidence from the account books of the period, Raphael worked on the *Disputa* in 1509 and 1510; that is, as soon as he finished the ceiling. A payment of early 1509 records a substantial sum, which either reflects a settlement for completion of the ceiling or an advance, on account, for the wall frescoes. On the basis of the style, it is usually agreed by specialists that the *Disputa* was Raphael's first wall fresco, and since at least two of the others have the date of 1511 connected with them, namely the *Parnassus* and the *Justice* walls, we can rather confidently place the painting to the time in between the ceiling and the other wall murals.

The *Disputa* serves within the larger program to elucidate the concept of "Theology," which is personified above and, it

will be recalled, is coupled with the *Temptation and Fall,* that necessary event for the coming of Christ and redemption.

In broad terms the decoration, as we have already seen, is predicated on the room's intended function as a library. That books are depicted prominently in the paintings, as they actually were intended to be in the room itself, consequently should come as no surprise. We may also comprehend the program as a kind of "summa," or summation of the totality of knowledge as it was perceived in the early sixteenth century, embracing Religion, Philosophy, Poetry, and Law. The sweep of knowledge, which was passed on in written form, is also explicated by the individuals who wrote the great texts represented in the library, or at least who contributed to the four fields of knowledge isolated on the walls. Thus, the frescoes present a theme that was dear to the Renaissance, and that occurs already in the previous centuries, in cycles known as *uomini famosi,* or famous men.

The private study, or *studiolo,* of Federigo da Montefeltro, duke of Urbino and a man Julius could easily have admired, might have served unconsciously as a model for the pope. Federigo was, after, all a famous general, as Julius aspired to be. Furthermore, Julius had close connections with the Urbino, and of course Raphael was intimately familiar with the ducal palace. In the *studiolo,* a combination of Virtues, some of which were actually painted by Raphael's father, and images of famous authors may be found, as is the case for the Segnatura. Many of the figures in the frescoes can be identified in three primary ways: by inscriptions, by conventionalized physiognomic characteristics, or by attributes closely associated with the historical personages.

In the *Disputa,* Christ with arms half raised on the central axis inscribed by a golden circle and enframed by winged putti heads is similar in attitude to Christ in depictions of the *Last Judgment.* Beside Him, also belonging to the same traditional arrangement, are Mary on our left (to the right hand of Christ) and St. John the Baptist on the other side. God the Father is shown blessing the entire company with his right hand while holding a globe with his left.

Putti in this paradisiacal vision hold up the four books of the Evangelists, paired on either side of the Holy Dove, who is on the same axis as the Christ and Good Father. Thus, implicitly but effectively, the Trinity dominates the *Disputa.*

On the same zone are a miscellany of twelve figures; reading from left to right, St. Peter with a book and key, Adam with legs crossed, the beautiful St. John the Evangelist in the act of writing, King David with a stringed instrument, St. Stephen, and the Prophet Jeremiah. On the other side of Christ we find Judas Maccabeus in armor, St. Lawrence with the grill tucked under his right arm, Moses with the tables of the ten commandments written in pseudo-Hebrew lettering, an unspecified Evangelist, St. Bartholomew (or, alternatively Abraham, as the image is more commonly identified) with a knife, and finally St. Paul with his characteristic sword. Old Testament heroes are distinguished from the others, as they are depicted without halos.

Even from this section alone we can see that the selection of personages is an eclectic mixture and for that reason probably reflects Julius's choices. For example, the presence of St. Francis is an indication of Julius's and his uncle's allegiance to the Franciscan Order, especially since there is no counterbalancing image of St. Domenic. It has been claimed with good reason that the overall program contains a Franciscan character since, after all, Sixtus IV before becoming pope was the General of the

Franciscan Order, and Julius was Cardinal Protector of the order before his election. The prominent placement of the warrior Judas Maccabeus is consistent with Julius's vision of his destiny. Indeed, he even told Michelangelo that it would be more fitting to portray him with a sword than a book.

The same pattern holds true for the lowest, or ground, zone of the *Disputa,* although not all of the figures are readily individualized. The personages seated around the altar table with the host are the four Fathers of the Church, specified by inscriptions in their haloes, and the book titles lying nearby, as Saints Gregory the Great and Jerome on the left, and Ambrose and Augustine on the right. They gesticulate among themselves, discussing and explicating the Eucharist. Other figures can also be recognized, including the well-known profile of Dante, who is included both here among the theologians, and again among the poets in the neighboring fresco, *Parnassus.* Recognizable as well are Saints Bonaventure, who is located between two popes (the full-length standing one being Sixtus IV), and Thomas Aquinas, representing respectively the two great preaching orders, the Franciscans and the Dominicans.

On the left are a small group of men including another Dominican often referred to as the painter Fra Angelico, but who is more likely St. Antoninus, one of the most influential theologians of the Renaissance.

The young man standing tall with flowing locks seems to be a reference to a contemporary, as is the old man leaning on the balustrade, often considered to be a likeness of Bramante, who also appears in the guise of Euclid in the *School of Athens.* Such an overlay between a contemporary member of the pope's (and Raphael's) circle and a personage from the past raises the likelihood that Raphael, in addition to using Greco-Roman sculptural portraits, depended upon models from the court for his facial types. Moreover, such an operation, which must have been intentional, would certainly have been quickly deciphered to the amusement of the interested parties. However one may wish to interpret the phenomenon, there are contemporaries within the cycle, the most important of which is the pope himself, who may be at least vaguely referred to in the guise of Innocent III, together with his papal uncle, Sixtus. Julius is more unambiguously present on the *Justice* wall. In this way, an air of timelessness, a historical meeting of the minds, persists in this fresco as well as in the others within the room. The distant past, the more recent past, and the present collide and overlap.

Although the *Disputa* is inevitably paired with the *School of Athens* on the opposite wall, Raphael painted next in chronological order the *Parnassus,* which he finished in 1511 (see pl. 18). Here the pattern of the *uomini famosi* theme is reinforced: we have historical persons from the Classical and the "modern" worlds united in a single space. The central image of Apollo playing a fiddle, or more accurately a *lira da braccio,* is exhibited in company with the allegorical renderings of the muses. Not all of them are identifiable with any degree of certainty, although Thalia can be seen holding the comic mask and Melpomene the tragic one. Clio, Calliope, and the others presented without traditional emblems may not be individualized with any degree of conviction; furthermore, all the muses lack inscriptions, which might have proved helpful. We may only speculate that the learned visitors to the room could have formed opinions about their identities.

The poets, who come from various epochs, are also without identifying labels, with the single exception of Sappho. This

massive woman seated on the left is the only female in the entire series among historical, in distinction to allegorical, figures. Many of the poets can be recognized without difficulty, however, including the blind Homer on the upper left, whose head at least is a conventional type known to the Renaissance from ancient sculpture. Dante is seen again, this time with his guide Virgil, so that we have in this grouping not only examples of epic poetry but of three great cultures, the Italian, the Greek, and the Latin. Others poets, and possibly some contemporaries, are found in the upper right, where Boccaccio and Petrarch seem to be depicted.

The most celebrated of the frescoes is the so-called *School of Athens,* a title that was applied several centuries after it was painted (see pl. 27). Here the pattern already seen of representing ancient and contemporary heroes is perpetuated and even accentuated, although the individual identifications are often increasingly obscure. Moreover, the emphasis is more strictly on the classical world of Greece and Rome, than upon the modern one. The two dominating images, Plato and Aristotle, hold books they have composed, *Timaeus* and the *Ethics* respectively, so no room is open for equivocation. Socrates may be the figure beside Plato, which would be apt.

In the grouping of figures located at the lower right, some interesting identifications may be postulated, although firm proof is lacking. Again, we find the balding Bramante used for the bending man, this time very likely representing the geometer Euclid, who draws generic diagrams on the slate board. Zoroaster, holding a representation of the heavens, appears to be the figure looking out of the space; he is paired with a crowned man, usually called Ptolemy, who, in turn, holds an earthly globe. Exceedingly provoking are the portraits of the two men who look out on the extreme right edge of the composition: we recognize the head of the youthful Raphael together with his teacher, Perugino (probably not Sodoma as is often proposed), functioning as a signature, which in fact is wholly absent in the entire room. Besides, it provides us with a private biographical note. (Perugino, then an old man, was in and out of Rome during these years and Raphael put his teacher to work in one of the other rooms.)

Pythagoras intently absorbed in writing is found on the opposite side of the *School of Athens.* We can also be reasonably certain that the partially nude old man lying on the steps is the philosopher Diogenes the Cynic. The handsome young man with the long hair looking out, the same model as the one in the *Disputa* and surely a contemporary, reappears, and with him a smattering of people whose specific appearance suggests that they are specific individuals. Some think Michelangelo is, in fact, embodied in the grandiose seated man, which is painted, to be sure, in Buonarroti's manner as exemplified on the Sistine ceiling. If these identities have validity, there is a (hidden) series of famous artists' portraits in the *School of Athens,* including Michelangelo, Raphael, Perugino, not to mention Leonardo, that has been associated with Aristotle and Bramante.

Ancient Gods may be found, though here not rendered in flesh and blood as in the ceiling or in *Parnassus,* but in the guise of marble statues in niches, Minerva on the right and Apollo on the left. The latter is represented here for the third time in the room.

The *Justice* or *Jurisprudence* wall has the least room for pictorial amplification, due to space occupied by the large opening for

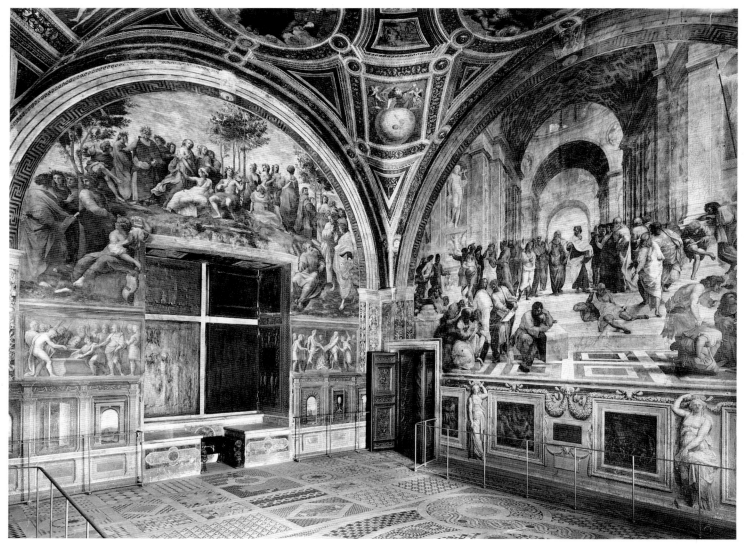

The Stanza della Segnatura, view of *Parnassus* and partial view of the *School of Athens*

the window, which may have induced Raphael to divide the composition into three distinct and separate fields (see pl. 23). In the early planning stages he postulated a unified single field like the others, but obviously had to accomodate himself to the situation. The lunette, which shows, reading left to right, Fortitude with the lion, Prudence looking into a mirror, and Temperance holding reins, flesh and blood female personifications, is an entirely independent unit, as are the other two. The frescoes on either side of the window, which are, in fact, disturbingly unequal between themselves, show Justinian receiving the Pandects on the left side and Gregory IX receiving the Decretals on the right. In the latter, especially noteworthy is the portrait of Julius II as Gregory, graced by a beard, in a familiar likeness. Thus we see that the pattern of Raphael's method of combining historical and contemporary figures is perpetuated.

As a virtual footnote to the Segnatura and its decoration, brief consideration should also be given to the inlaid marble floor, which from the paltry evidence that has come down, appears to have been completed sometime before Raphael began to paint the room (see left). Yet the design, which represents, like the floor of the Sistine Chapel, a revival of Byzantine medieval programs, has no purely representational imagery but only geometric designs. Of very considerable sweep and power, they retain rapport with the rest of the room to produce a totally rewarding and convincingly unified experience. Moreover, four tondi within this design contain Julius II's name, and thus serve to link the patron to every aspect of the room.

A sense of the complexity of the Stanza della Segnatura can now be appreciated. A prodigious body of knowledge, hundreds of figures of all ages and types, intricate interrelations among the parts and within the various subdivisions are all balanced by rigorous pictorial compositions. In the final analysis, beyond the miracles of his figural inventions, Raphael's merit in the Segnatura is the impression of harmony, clarity, and comprehension.

PLATES & COMMENTARIES

I. View of Stanza della Segnatura

The Stanza della Segnatura is a smallish space, measuring hardly 27 by 21 feet. Yet the overall effect of the decoration explodes beyond the physical dimensions by providing broad, visually convincing apertures on the walls and on the vaulted ceiling. The painted scenes, revealed under majestic stage-like arches, are essentially narratives that are revealed in either vast interiors or expansive landscapes; shown here is the *School of Athens*. The room, which seems to have been originally planned to be used as a library, is one of four interconnecting chambers located between the Vatican's Cortile del Pappagallo and the Cortile del Belvedere, oriented almost precisely north-south. Presumably the books were intended to be placed in cabinets in the middle of the room. However, it is unclear whether the room ever actually functioned as a library. By the middle of the sixteenth century, if not much earlier, the Segnatura housed the Tribunal of the Curia, from which it has obtained its name.

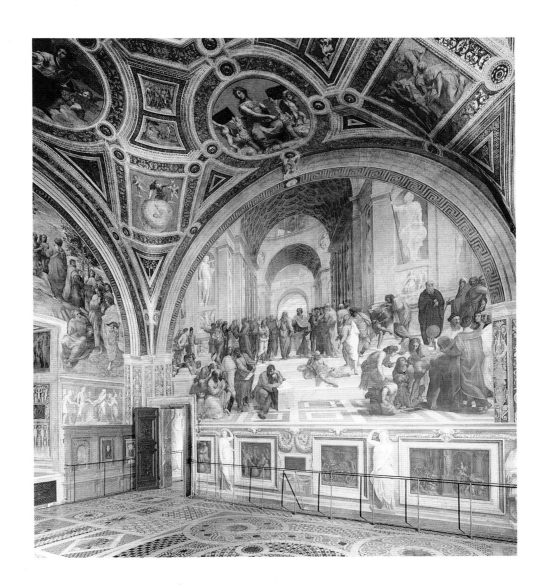

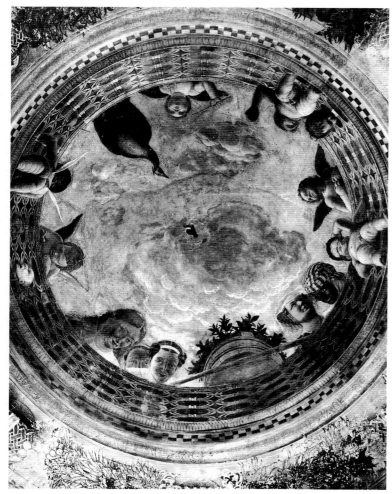

Andrea Mantegna, ceiling oculus, Camera degli Sposi, 1474, fresco, Ducal Palace, Mantua

2. OVERALL VIEW OF THE CEILING

Aplan for the vault was devised and partially executed before Raphael was called into the project during the second half of 1508. Artists who are thought to have had a share in that early stage include Sodoma and Bramantino, but their work seems to have been almost entirely cancelled, except for grotesque decorations and small panels that Raphael apparently retained. The papal coat of arms is at the center of the vault enclosed within an octagon. The four rondels with personifications of Theology, Justice, Philosophy, and Poetry set the stage for the entire program, which is elaborated and explained in the frescoes on the walls. They are separated by four rectangular representations to which they are closely related in meaning.

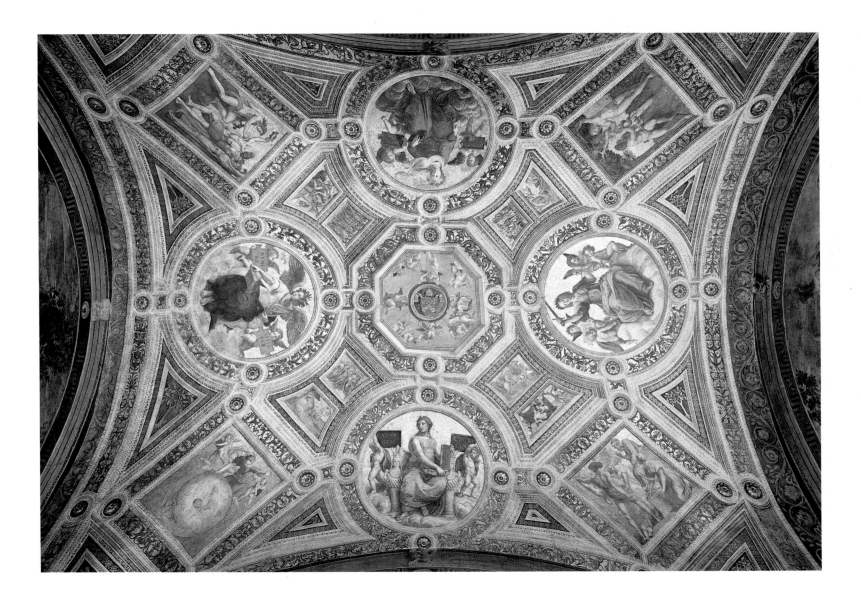

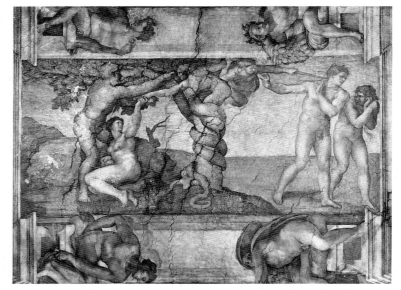

Michelangelo, *The Temptation and Fall of Adam and Eve,* ceiling of the Sistine Chapel, 1508-12, fresco, Vatican

3. THE TEMPTATION AND FALL OF ADAM AND EVE

E ve stands in an easy contrapposto as she balances upon a branch of the densely foliated tree in the center of the composition that separates her from Adam. Eve holds a tiny fig, which is interpreted here as the fruit, rather than the apple, which caused the first children's disobedience. Adam, seated, turns his upper body in Eve's direction as he looks up to her somewhat imploringly, reaching for the forbidden fruit. Satan, in the guise of a serpent twisted around the tree, has the torso and head of a woman, and appears to be orchestrating the entire drama. The painting in its rectangular field reveals a strong diagonal thrust (from Adam's feet to his right forearm and hand shown in front of the tree to the arms and shoulders of Eve), which virtually points to *Theology,* to which it is thematically connected.

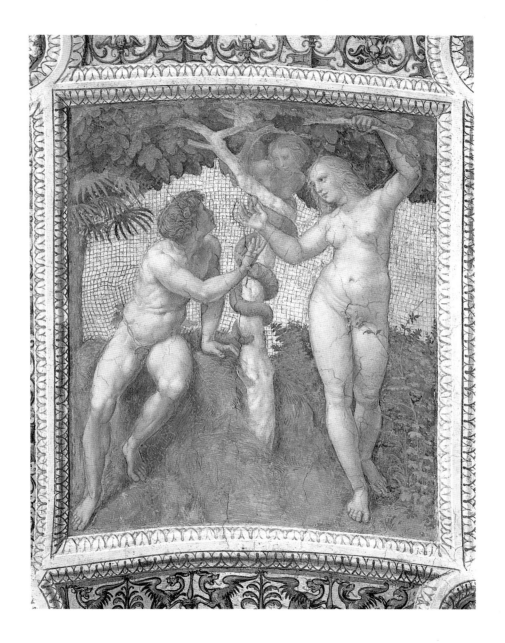

4. Theology

The personification of Theology points down with her right hand toward the fresco representing the *Disputa* immediately below her. The woman is clad in a flowing white veil, green cape, and red dress, colors that are associated with the theological virtues of Faith, Hope, and Charity. This color symbolism may relate to other parts of the ceiling, including the dress of Philosophy, and may also stand for the elements. The two putti, who are this time not entirely nude, are actively posed, as if engaged in a children's dance. They hold plaques that together read: DIVINAR[UM] RER[UM] NOTITIA, a phrase taken from Justinian, who figures as an important personage in the Segnatura. Beneath her are dark clouds unlike those in the other ceiling tondi. In his figural style Raphael shows himself here to be moving away from that of his master, Perugino, as well as another slightly older favorite pupil, Pinturicchio, and toward a more robust conception that will define his new Roman manner, one in which a knowledge of the Florentines, but also Signorelli, can be detected.

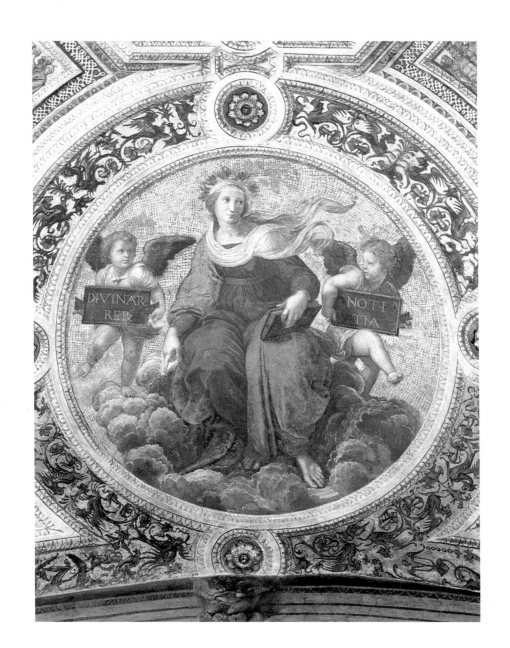

5. APOLLO AND MARSYAS

In terms of the other scenes, the quality of the figural invention seems somewhat static, which has led earlier critics to see the brush of another artist in this panel. On the other hand, the language appears to be Raphael's at the first stage of his entry into Rome. Here Apollo is shown seated on a rock throne with his lyre about to be crowned by a somewhat indecisively rendered male nude with his back to us, who stretches his right arm awkwardly. On the other side of the composition, Marsyas, hanging by his arms as he appears in classical sculptures, is stretched to the maximum, his toes barely touching the ground, so that his body would be as taut as possible, in order to more effectively receive his punishment for challenging Apollo. Its meaning it can be interpreted as an ancient parallel to the *Temptation and Fall of Adam and Eve,* which is depicted nearby. Marsyas, who had picked up a flute discarded by Athena, became so skillful at playing it that he challenged Apollo, the patron god of the lyre, to a musical contest. The muses, whose representations appear with Apollo's in the *Parnassus* in the zone below, judged the winner to be Apollo. The god then had his would be challenger skinned alive.

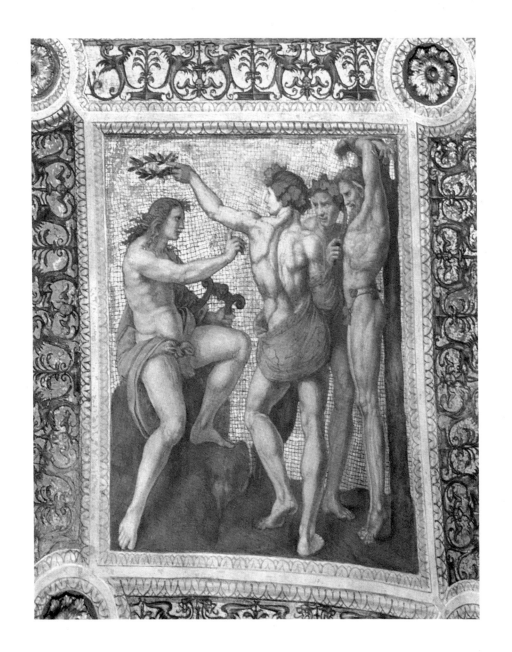

6. Poetry

Poetry is the only female personification on the ceiling that has wings, perhaps a reference to the soaring imagination of creativity. Her inscription, "NUMINE AFFLATUR," refers to inspired, frenzied genius and comes from the *Aeneid* (Bk. VI, 50) by Virgil, who appears in the scene below. Cross-legged, Poetry sits on a cloud bank as do the others. Her right arm is pushed forward rather dramatically; with the other arm, which rests on a classical head, she supports a lyre. Behind her, as is the case with all of the major scenes on the ceiling, we find an imitation gold mosaic background, a remarkable painted feature that seems to connect the ceiling with the inlaid mosaic floor of the room, and one that increases the illusionism.

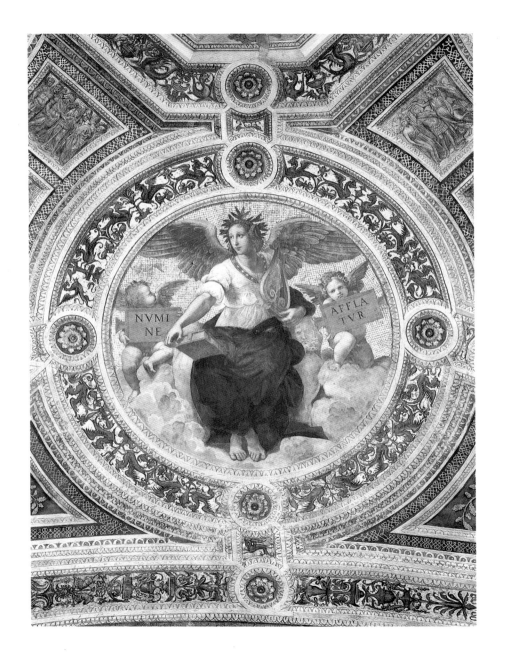

7. PRIME MOVER

The identification of this panel is the most difficult to verify among those on the ceiling. It appears to be related to the concept of the origins and harmony of the universe. The woman rests her right arm on a starry sphere, which appears similar to the starry sphere held by Zoroaster in the *School of Athens* below (see pl. 31). She gestures in the direction of *Philosophy* with her left hand. On either side of the figure, sometimes also referred to as *Astrology,* or *Urania,* are winged putti holding the ever ubiquitous books. In this case the golden mosaic background is generalized, not giving way to an earthly ground, like the others.

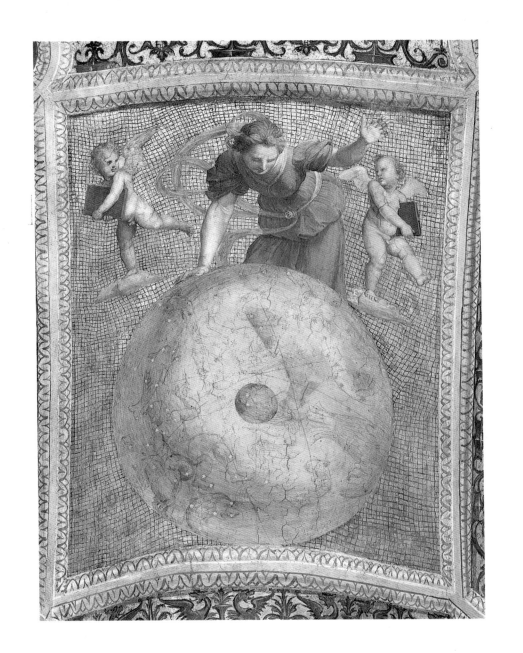

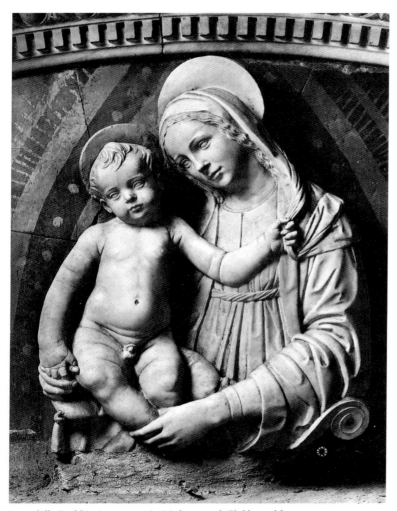

Luca della Robbia (1400–1482), *Madonna and Child,* marble,
Santa Maria della Grazie, Arezzo

8. PHILOSOPHY

The representation of Philosophy manifests sophisticated references from the ancient world. She sits upon a marble throne that contains the image of the many-breasted Diana of Ephesus, whose body, which is repeated twice, is covered with hieroglyphics. The personification holds books, one with the inscription "MORALIS" and the other with "NATURALIS." Conceived in a vigorous contrapposto, her right arm is thrust across the body to support the book on the left leg. Her upper torso is turned toward the right, while her head is turned in the opposite direction, in a pose first elaborated upon by Leonardo da Vinci. The playful putti are full of lively movement. As types they reflect Raphael's experience in Florentine sculpture, especially that of Donatello and Luca della Robbia. Philosophy's robe once showed four colors representative of the four elements: blue (air), red (fire), green (water), and yellow (earth).

9. JUDGMENT OF SOLOMON

The muscular soldier with his menacing sword is about to divide the child he holds by the feet, upside down, since the two women had disputed over who was the real mother. The woman to Solomon's right pleads for the child's life, as she reaches to grab the executioner's arm. Her action, according to the biblical episode, discloses to King Solomon that she is the true mother and she is awarded the child (Kings III:4). Here, as in the *Apollo* and the *Punishment of Marsyas,* a diagonal movement can be determined from the lower left to the upper right, leading the eye to *Justice,* and reminding the viewer of how tightly interconnected are all of the scenes on the ceiling. Julius might have associated himself with Solomon, since his St. Peter's, then under construction, was thought of as the new Temple of Solomon.

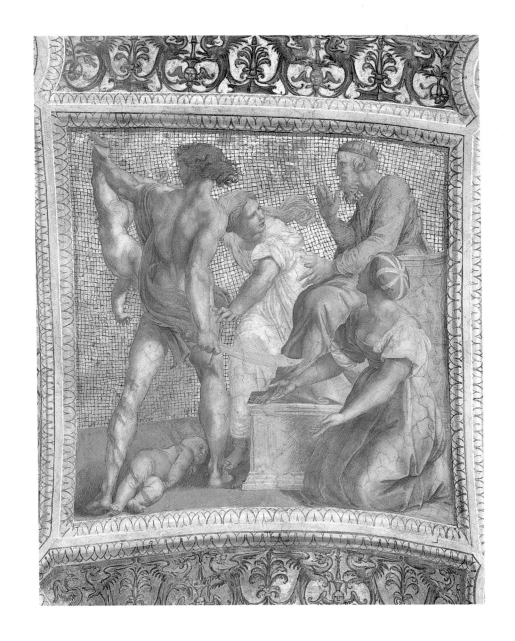

10. JUSTICE

Brilliantly composed within the circular configuration, *Justice* holds her traditional attributes, a sword with her right hand and scales with her left. The head of the woman is small in relation to her body, while the features are still those petite and delicate ones found in the young Raphael. The four putti, in diverse and highly activated poses, support tablets that bear an inscription taken from Justinian, who is depicted in the narrative painted in the zone below. Their placement also underscores the shape of the wide frame.

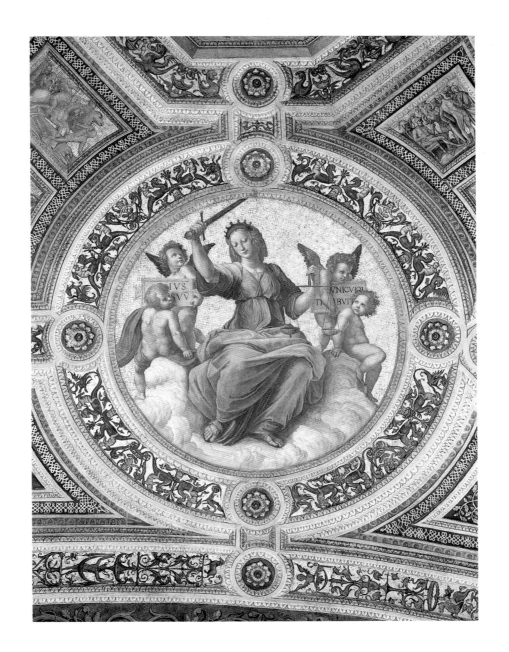

11. Dispute over the Sacrament

The entire fresco, which is usually, if somewhat imprecisely, called the *Disputa,* is presented as if suffused by a warm, almost golden light. Divided horizontally into three distinct zones, the geometric form of the circle and segments of the circle dominate, beginning with the sweeping curve of the lunette itself. In the uppermost zone, a golden angelic vision in which God the Father dominates is constructed as part of a crowning apse. Moving down to the next level, we find twelve seated figures from the Old and New Testaments together with Saints, all on clouds. Christ is located on a slightly raised cloudy platform together with Mary and St. John the Baptist. On the earthly level, the altar is the visual center, around which figures are disposed on both sides. As backdrop to the scene on the lowest level is a delicate landscape on the left and, on the other side, a simply decorated marble building rendered in Bramante's architectural style.

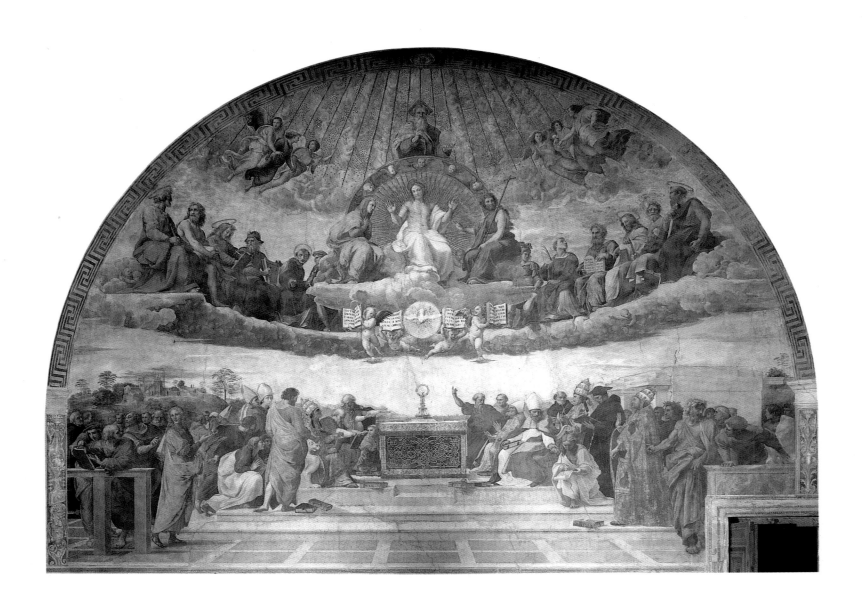

12. Disputa, lower left

R aphael constructed the *Disputa* as a unification of groups of figures, or in some cases single figures. In this area, a figure, with an all-important book, gestures in the direction of the open pages but he looks away toward the central area of the painting. This representation, usually understood as bearing the features of Raphael's prime supporter in the papal court, the architect Donato Bramante, acts as a visual entrance into the intricate composition. He leans over a finely rendered marble balustrade, touching the picture plane with his forearm. An interlocking function is played by the standing youth with the long hair, possibly the pope's favorite nephew, Francesco Maria delle Rovere, who points toward the central group displaced around the altar. That is to say, the eyes of the spectator are directed by gesture, glance, pose, and perspective to the altar and host. In the background in the lowest zone is a landscape revealing a building under construction, perhaps a reference to the building occurring under Julius II's authority.

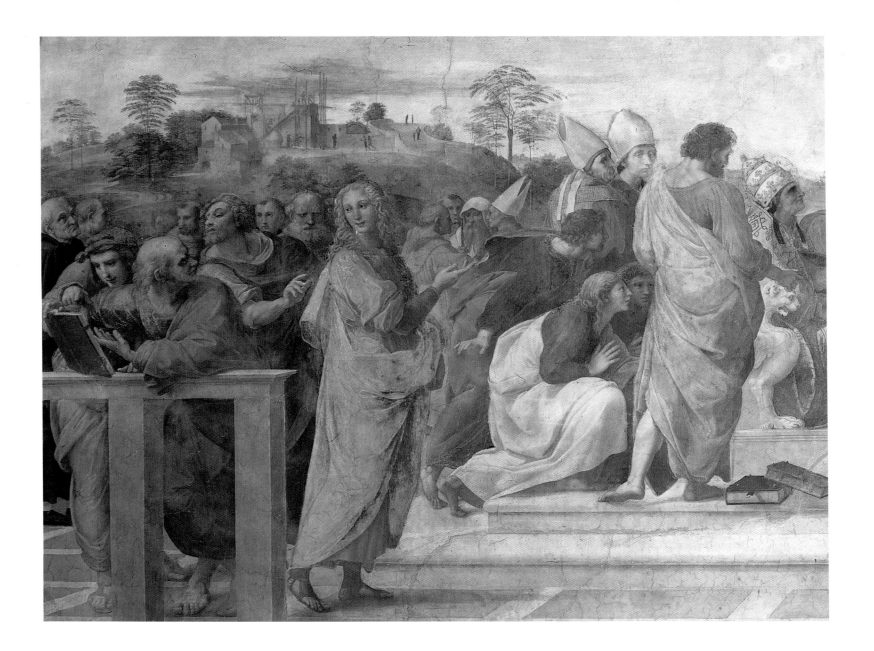

13. Disputa, Altar area

The composition of the painting is calibrated by the large marble slabs on the ground with its carefully worked out perspectival system. The orthogonals lead the eye directly to the altar and most specifically to the monstrance and the host located on it. The Church Fathers are arranged around the altar: Saints Gregory the Great and Jerome on the left and Ambrose and Augustine on the right. References to the reigning pope and patron of the decorations is found in two inscriptions on the altar table's face. Furthermore, some critics have found his likeness, before he grew a beard, in the representation of Gregory. The raised hand and pointing finger of the figure behind St. Ambrose bring the attention of the company to the sacred zones above; this figure, as well as others in this scene, reminds us of Raphael's enormous skill at treating gesture.

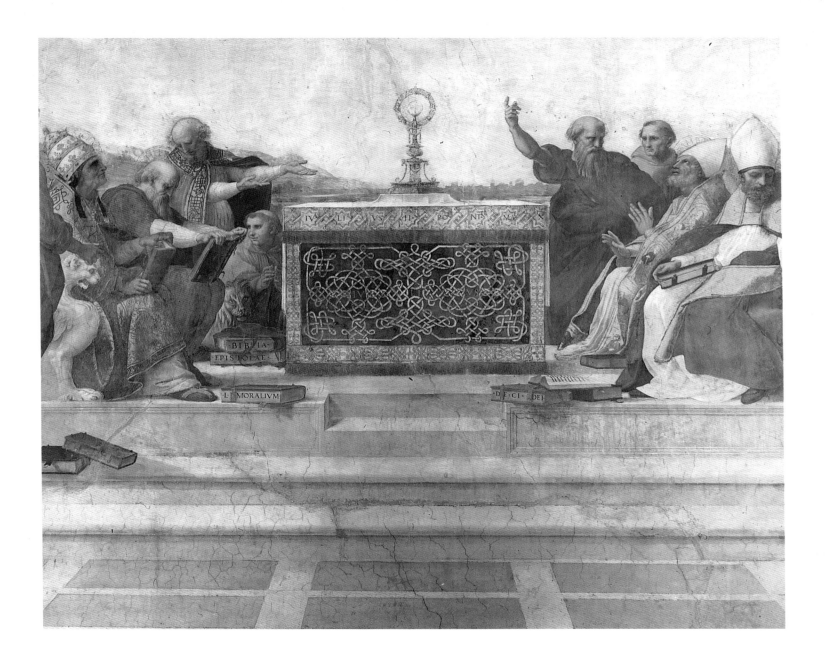

14. DISPUTA, LOWER RIGHT

While a balance is disclosed with its counterpart on the left, sufficient variety has been injected in this part of the fresco to engage the viewer's interest. We also continue to see recognizable historical personages like Innocent III and Julius's uncle and mentor Sixtus IV, the latter clearly identified by the book that lies at his feet, *De Sanguine Christi*. In papal garb, the standing Sixtus transfers his gaze to the axis of the Trinity, as he raises his hand in awe. Behind him, the profile of Dante, who is shown both in the *Disputa,* as a theologian, and in the *Parnassus* as a poet, is readily ascertained. Raphael had to accommodate his composition to a real doorway at the right side of the painting; in order to decrease the disturbing aperture, he used it to raise a fictive balustrade upon which a youth leans.

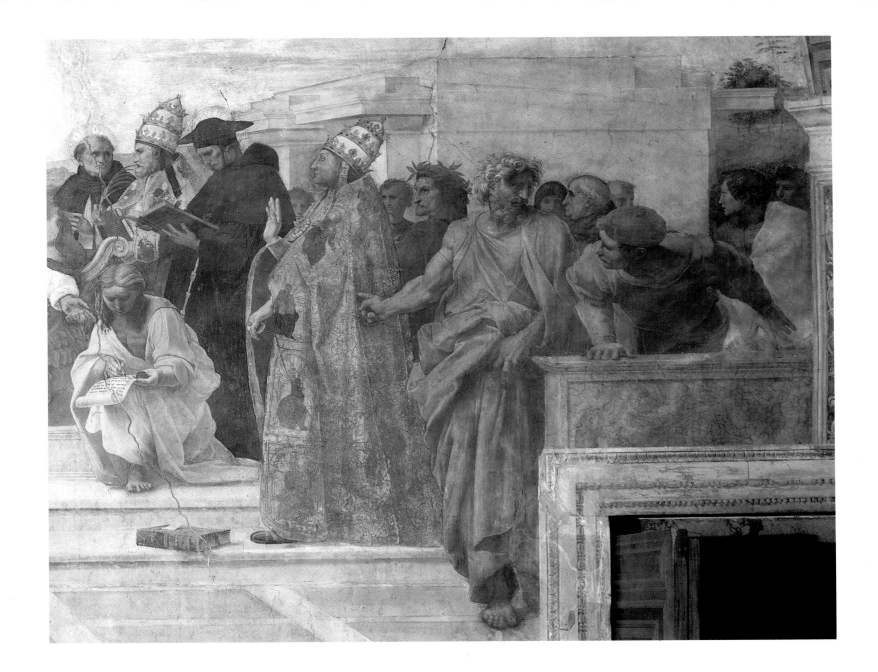

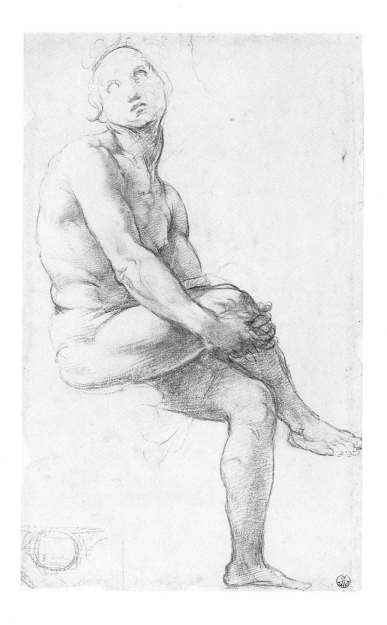

15. DISPUTA, UPPER LEFT

The twelve figures distributed around Christ are more isolated, one from another, than those in the zone below. Their identities are also readily determined (see page 21). However, they are, if anything, stylistically more stiffly conceived, leading to the probability that they were executed earlier, as normal working modes would have us believe. Furthermore, they offer the assumption that this was the first of the large frescoes that Raphael painted. The *Disputa* is particularly well documented by surviving drawings, and in many cases (as with the Adam, the second figure in this group), figures were studied first from the nude. This drawing may well have been the source of other figures in the Segnatura, such as the young scribe next to Homer in the *Parnassus* (pl. 18) and the cross-legged figure in the middle of the right side of the *School of Athens* (pl. 27). Quite understandably, given the papal patronage of Rome, St. Peter, who looks inward in Christ's direction, is given a privileged position as the first figure in the group, matched by St. Paul on the opposite side.

Raphael, *Study for Adam in the Disputa,* 1508–9,
Gabinetto Disegni, Florence

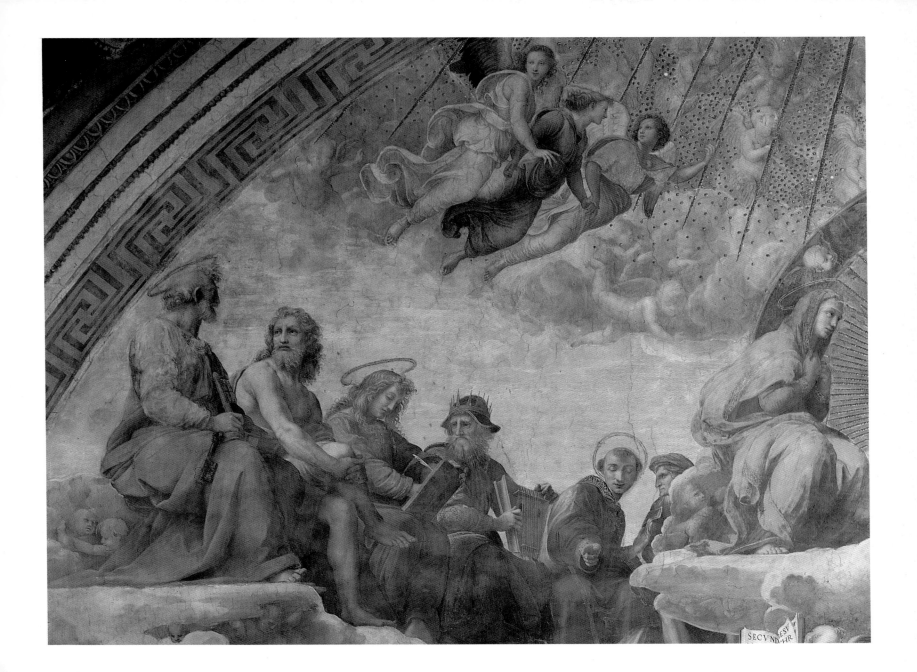

Raphael, *Study for Christ in the Disputa,* 1508–9, Collection Wicar,
Musée des Beaux-Arts, Lille

16. DISPUTA, UPPER CENTRAL, WITH CHRIST

The central axis of the painting, upon which the Trinity is revealed, may also be read as an interaction of round forms. Enclosed within the segmented circle of the lunette itself, and repeated in the circular halo that surrounds Christ, a golden disk constitutes the field for the Holy Dove beneath Christ's feet. Mary, full of humility at the right hand of Christ, finds her complement in the mature Baptist, wearing his traditional cloak of animals' skins and holding his reed cross. Putti below hold the four books of the Evangelists. All of these circular configurations underscore and reinforce the shape of the Host, which is on the same axis on the zone below. On the very apex of the composition, God holds the globe, further reintegrating the reiterating circular theme.

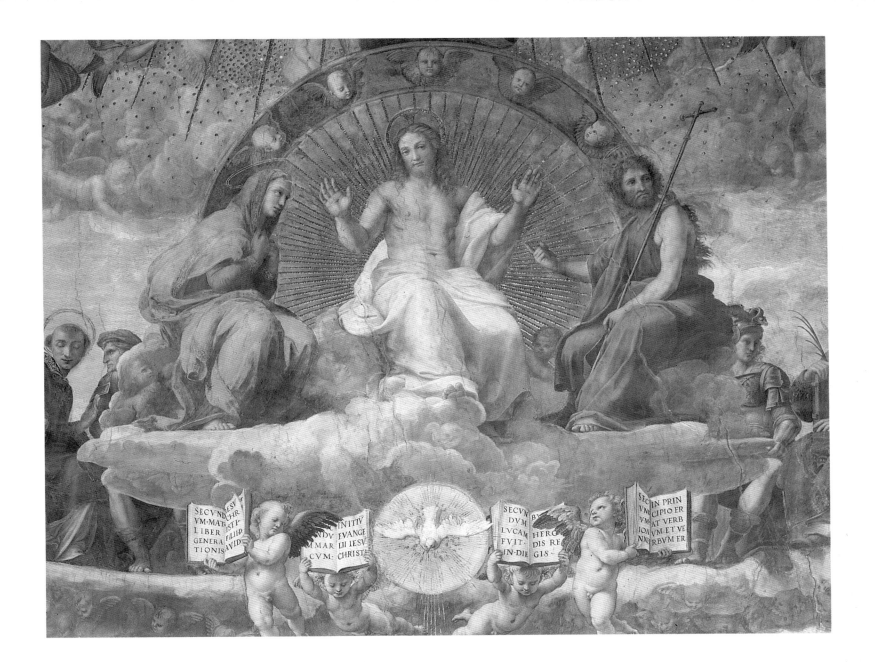

17. DISPUTA, UPPER RIGHT

The image of Judas Maccabaeus, who is closest to the central section, may be another reference to Julius II. This man was a military hero of the Old Testament. In this section, in particular, one may ask whether Raphael executed all of these images himself or whether one can isolate the contributions of assistants or collaborators, which he used widely to great effect later on in his career. Here it appears that we are dealing with Raphael's hand virtually unaided, as is true for all the frescoes on the walls of the Stanza della Segnatura. At the same time, one can observe a gradual change in his personal style, one that moves toward an increased monumentality and classicality during the very years when he was painting this room; and even within the *Disputa* itself, from the tighter, more restrictive treatment in the upper zones, to the looser and more self-confident flavor of the lowest section.

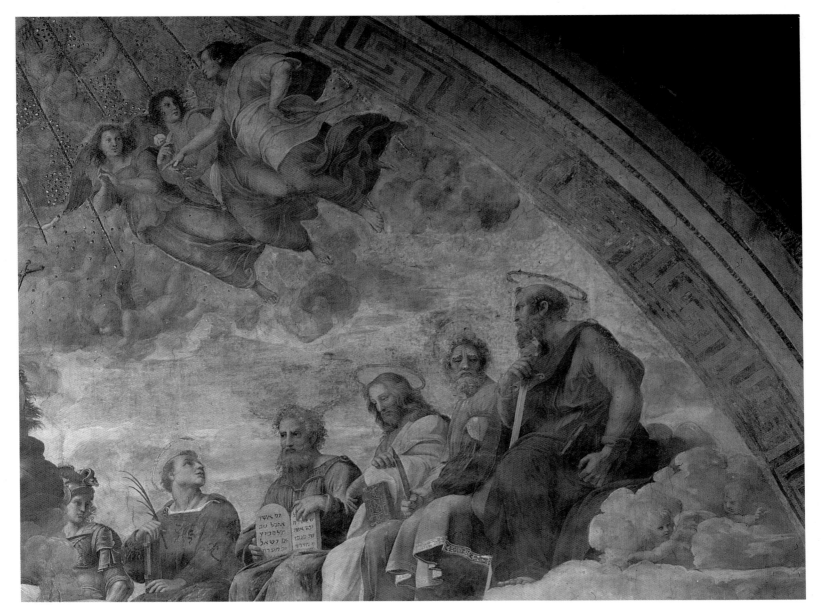

18. PARNASSUS

The composition of this fresco has been conditioned by the substantial window open-ing, upon which the painter elaborated the hill of Parnassus, a mountain in southern Greece, sacred to Apollo and the muses, globally considered to embody the concept of poetry. An outcropping of rock is the base upon which the upper zone of figures is located. Flowing water is found in the center of the picture, a reference to the predilection of the Muses for certain springs. Laurel trees, from whose leaves crowns of poets are fashioned, dom-inate the landscape at the top. At the sides, where Raphael had more space at his disposal, he created figures that seem to break the pictorial surface and enter into the space of the room itself. In this manner, the spectators can penetrate into the narrative, either on the left or on the right, and move up the low hill, descend, and finally exit from the pictorial world and reenter the real one.

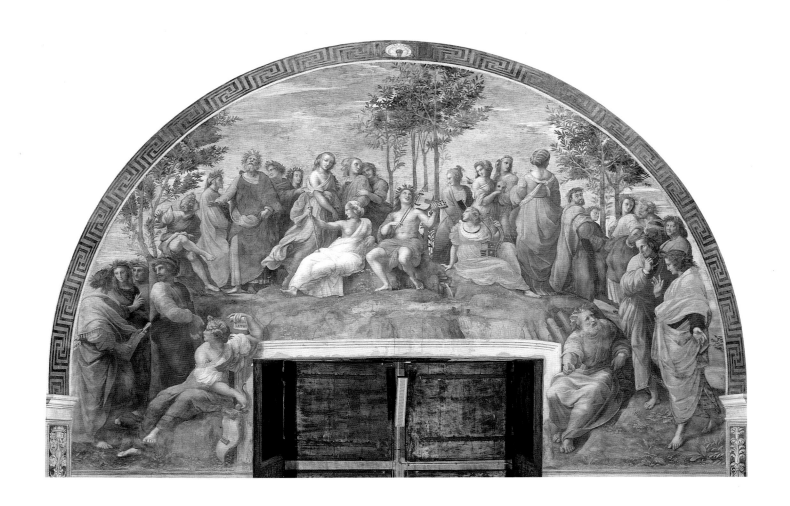

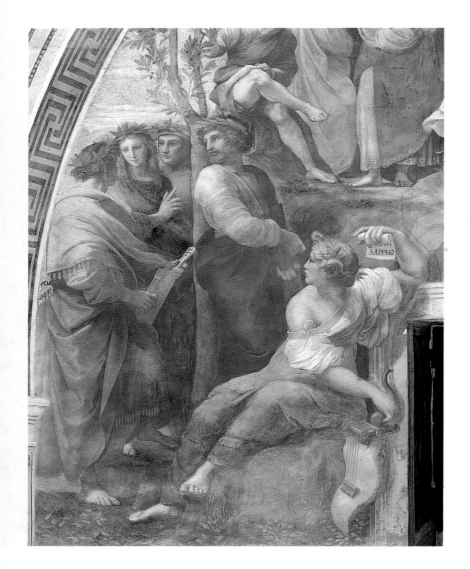

19. Parnassus, lower left, with Sappho

The dominant representation in this zone and indeed in the entire fresco is the seated Sappho of Lesbos, who leans on the painted architecture with which Raphael had enclosed the real window. Identified by a partially opened scroll with her name, she holds a four-stringed lyre with her right hand. The pose is full of internal movement as she vigorously turns her head to the right toward a colleague, while her upper body is faced in the opposite direction. Raphael has here emphasized the three-dimensionality of this massive figure by clearly defined shadows that fall upon the marble architecture.

20. Parnassus, lower right, with 'Horace'

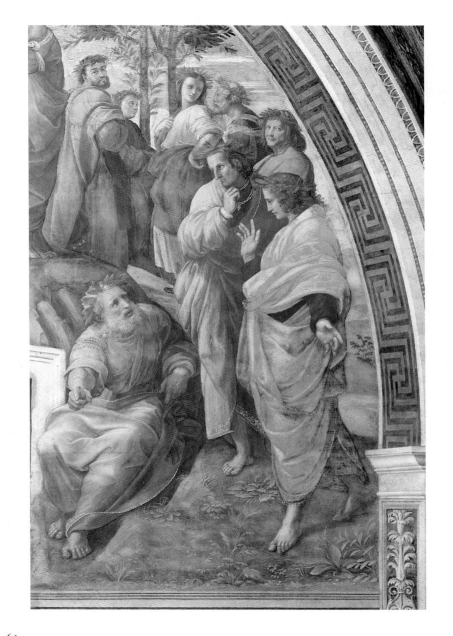

In these groups of ancient and modern poets, one has the impression that there are personages or likenesses that would have been quickly recognized by the papal courtiers. At least Vasari has sought to identify some of them, but his efforts have not won wide acceptance. The man standing near the top and looking out has been diversely identified: even Michelangelo's name has been offered, for he too was a skilled poet. In this area of the picture, one can recognize the way Raphael has connected the various figures; the so-called seated Horace balances Sappho, and looks upward to the man in blue with outstretched arms. The figure behind turns his glance back to Horace, generating a web of interactions, all of which are always, in Raphael, subservient to the meaning and dignity of the whole.

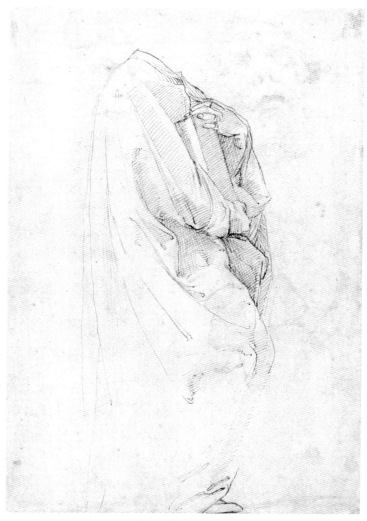

Raphael, *Study for Dante and the Head of Homer*, 1511,
The Royal Collection, Windsor Castle. Copyright © 1993
Her Majesty Queen Elizabeth II

21. Parnassus,
upper left, with Homer

Raphael's approach of arranging figures into significant coherent groups is well illustrated here, with Homer shown together with three other poets—Dante to his left, Dante's guide, Virgil, who looks back at the Florentine poet, and another man farther to the right. This group, all of whom have laurel crowns, is given a further expressive dimension by the attentive lad, presumably Homer's scribe, who sits cross-legged in a pose that Raphael developed for the Adam of the *Disputa*. In representing Homer, the author of the two grand Greek epic poems, the *Iliad* and the *Odyssey,* Raphael here reveals another aspect of his skills. His portrayal of the blind poet, who tilts his head and stands uneasily, is undoubtedly based upon the careful observation of blind persons, but confirmed by a Classical bust.

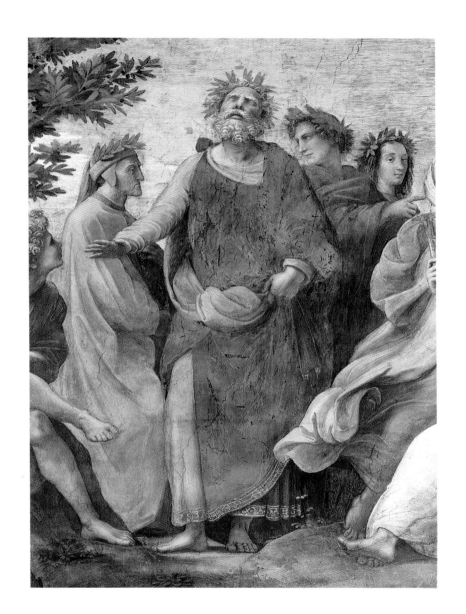

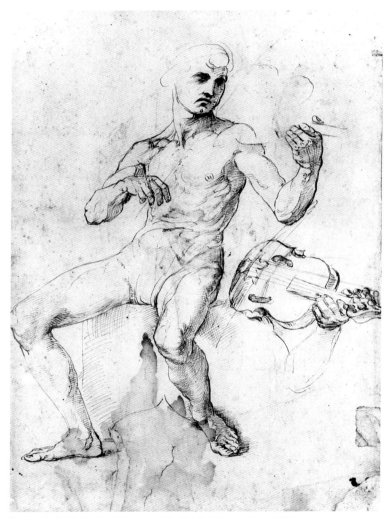

Raphael, *Study for Apollo*, 1511, Musée des Beaux-Arts, Lille

22. PARNASSUS, CENTRAL SECTION, WITH APOLLO

Apollo, god of light, is also the god of poetry and song, which is his role in the fresco. The seated man looks upward as he plays the stringed instrument, whose strains of song seem to penetrate the company, gradually gaining the attention of the nine Muses that surround him. The figure, thought to be Virgil, also gestures towards Apollo from the left side of the painting. Based upon a careful drawing, not only the figure but the placement of the hands on the instrument and the instrument itself have been rendered with convincing realism and attention to verisimilitude. The Muses, four on the left and five on the right, are presented in varied poses demonstrating Raphael's mastery in representing diverse aspects of the human body. Several are reclining, others standing, and one is shown from behind. The pale tones of their garments remind us of Raphael's remarkable gifts as a colorist. Furthermore, he insists upon variety, in contrast to the working methods of his teacher, Perugino.

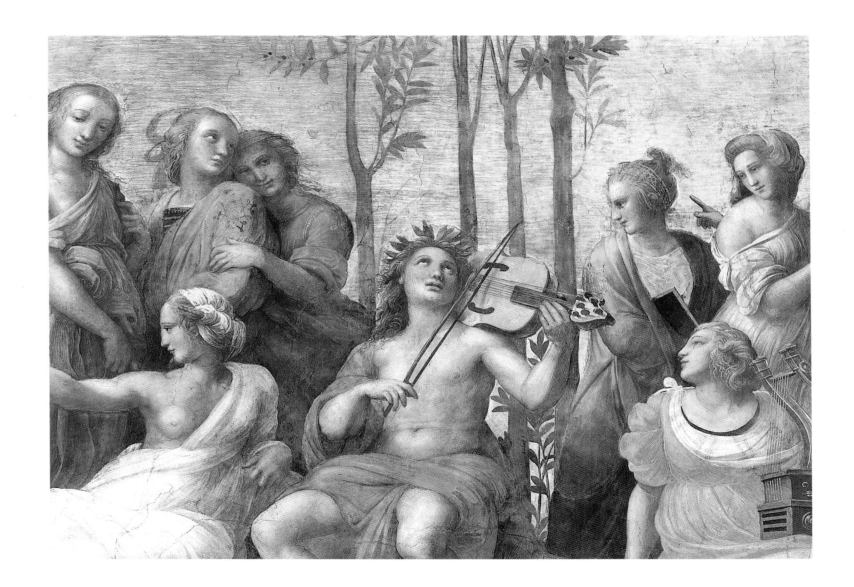

23. Virtues

Raphael has established a truncated lunette within an architectural framework including a heavy cornice and the two scenes below, articulated by pilasters. Here three massive female personifications represent from left to right, Fortitude, Prudence in the center, and Temperance. They are accompanied by five winged putti, three of which have been considered as referring to the three theological virtues: Faith, Hope, and Charity. The one on the right placed in profile but whose face is turned outward, points upward, perhaps to the ceiling with its imagery. As a figural type, it is derived from Raphael's Florentine experience and, more specifically, to Luca della Robbia. This engaging figure (Hope?) offers an entertaining counterpoint to the more serious elements in the program, and as a form saw a functional echo in Raphael's later works, including the *Sistine Madonna* (Dresden). The expressive potential was recognized by later artists, including Pontormo and Rosso Fiorentino.

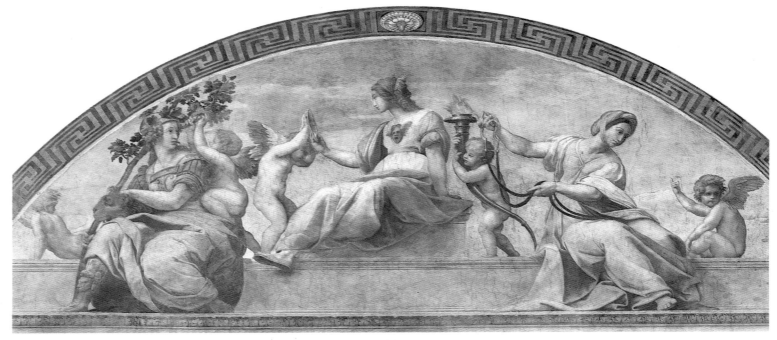

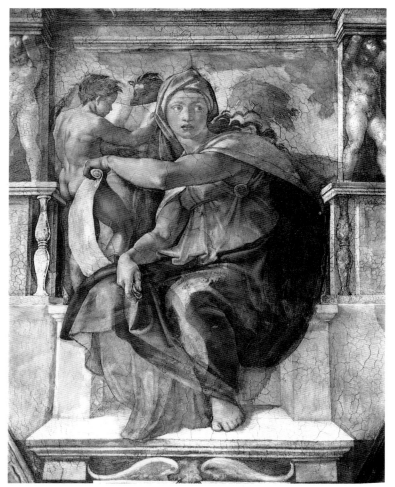

Michelangelo, *Delphic Sibyl* from the Sistine Chapel ceiling, 1508-12, fresco, Vatican, Rome

24. FORTITUDE

A sister to the *Sappho* as a figural type, the *Fortitude* has a massive presence that must be the result of Raphael's growing awareness of Michelangelo's Sibyls on the Sistine Chapel ceiling. Just as he early virtually outdid Perugino in his own style, here Raphael participates in Michelangelo's figural manner yet manages to instill into it, if anything, more grace and Classical beauty. This helmeted woman must be understood in rapport with Pope Julius, not exclusively due to the military references (the figure has armor), but because she holds a branch of an oak tree while the putto at her side reaches for the acorns. It will be recalled that the oak is a symbol of the pope's family, the della Rovere. Furthermore, the ferocious lion on her lap and shown on her boot may be understood both as a representative attribute of Fortitude, but also of *terribile* Julius himself.

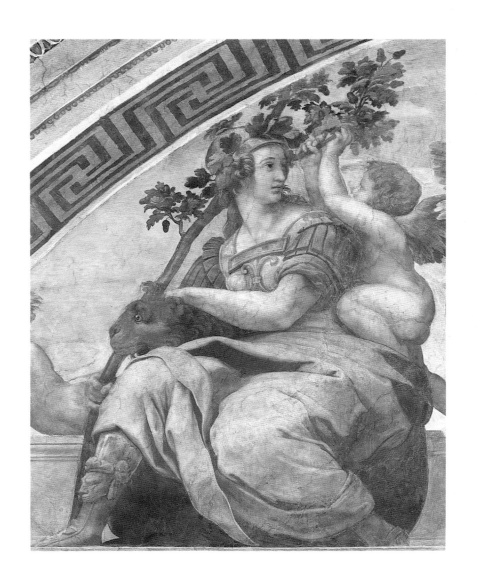

25. JUSTICE WALL, LEFT PANEL, TRIBONIANUS HANDING THE PANDECTS TO JUSTINIAN

The Pandects were a compendium of Roman civil law produced by the order of the sixth century Byzantine Emperor Justinian that became the basis of Roman law as it was passed on to Europe in the Middle Ages and Renaissance. The scene about this subject in the Segnatura has deteriorated severely over the centuries, possibly due to poor preparations and, unlike the others, has seen serious and evidently inexpert repaintings. The poor condition, a mere shadow of the original, has given rise to suggestions that Raphael did not himself paint this section. On the other hand, several preparatory drawings at least prove Raphael's invention of the composition. The frescoes treating *Justice* were finished in 1511 according to an inscription found directly over the window.

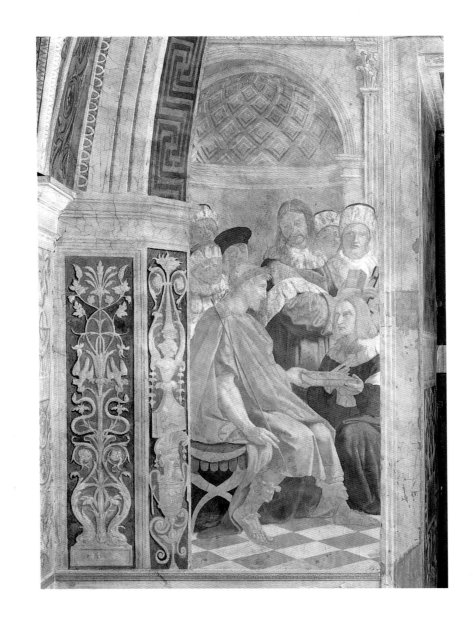

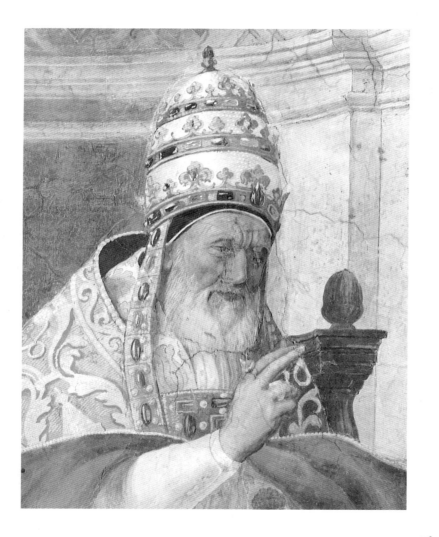

26. Justice Wall, right panel, Gregory IX Approves the Decretals

The Decretals constituted a collection of papal decrees that were formulated by Pope Gregory IX in the Middle Ages and that established the basis of ecclesiastical, or Canon, law, as the Pandects did for civil law. Better preserved than its counterpart, this fresco is unified by means of the checkered floor pattern as well as the coffered niches that serve as a background for the central events pictured. It should also be noticed that the two side frescoes are connected by a common perspective. The composition of this fresco is, if anything, more classical in disposition than its counterpart, with the standing figures displayed in a row, much like a colored marble frieze behind Gregory. A noteworthy aspect of this panel is that the thirteenth-century pope has the facial features of Julius II, with the beard that had been shaved off in early 1512. The termination date of 1511 of the work on the *Virtues* and upon the entire room is confirmed by an inscribed date. We also find references to Julius on the grand cape he wears. Here too, the condition of the frescoes has been compromised, making aesthetic and attributional conclusions somewhat questionable. The head of Gregory, which reveals later repaint, remains extraordinarily impressive.

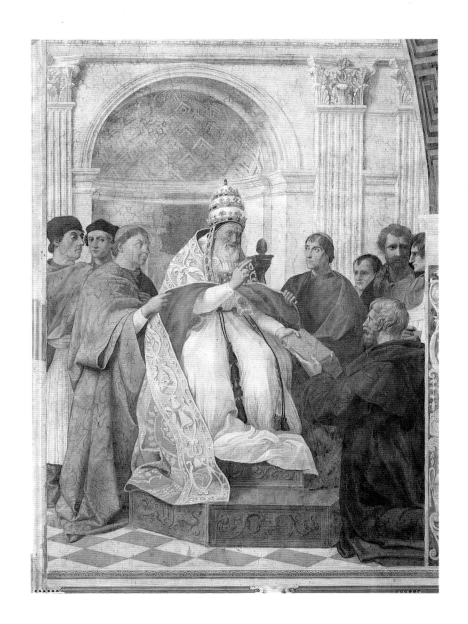

27. SCHOOL OF ATHENS

A true complement to the *Disputa* located opposite to it, the *School of Athens* is a glorification of the Ancient pre-Christian world, as seen through early-sixteenth-century eyes. Justifiably the most famous fresco painted by Raphael, and among the handful of masterpieces of the period, the picture has few equals. In subject matter, the greatest philosophers of Antiquity are pictured here starting with Plato and Aristotle, who are set apart and isolated from the others by a series of vast vaults that are open to the sky. In fact, the emphasis on the cool colors, the blues, and off-whites are in clear distinction to the golden tonalities in the *Disputa,* and seem to emphasize logical and rational as opposed to theological or spiritual values. Compositionally, the emphasis is strongly horizontal, with the main figures on a platform up several short steps, and reaffirmed in the zone below, in distinction to the *Disputa* with its vertical stress.

28. CARTOON FOR THE SCHOOL OF ATHENS

The most remarkable object of its kind surviving from the Renaissance and perhaps from any period, this cartoon by the hand of Raphael was prepared from many sheets attached to one another. Here he worked out the main figural sections of the *School of Athens,* using black chalk and white highlighting. By pricking the surface and then blowing charcoal through the little holes he transferred the drawing onto the wall, or as in this case, onto another paper that was used to conduct the actual painting. The technique of the cartoon, in which all of the intricacies have been worked out in light and shadow, recalls the way Leonardo worked, especially on the unfinished *Adoration of the Magi* (Florence). The section on the lower right seems particularly close to Leonardo's formula in the way forms are "pulled out" from dark zones. The robust figure seated beside a marble-block desk as he writes with his right hand and holds his head with his left, an image usually referred to as Heraclitus, and which has been referred to as a portrait of Michelangelo, is absent from the cartoon. Thus it must have been an afterthought, perhaps done while Raphael was actually painting. Probably he sensed that the lower central space was too bare and needed to be livened up. Also absent from the cartoon are Raphael's own portrait and that of his teacher, Perugino, the assumed identity of the man standing next to Raphael in the finished fresco.

(pages 80-81)

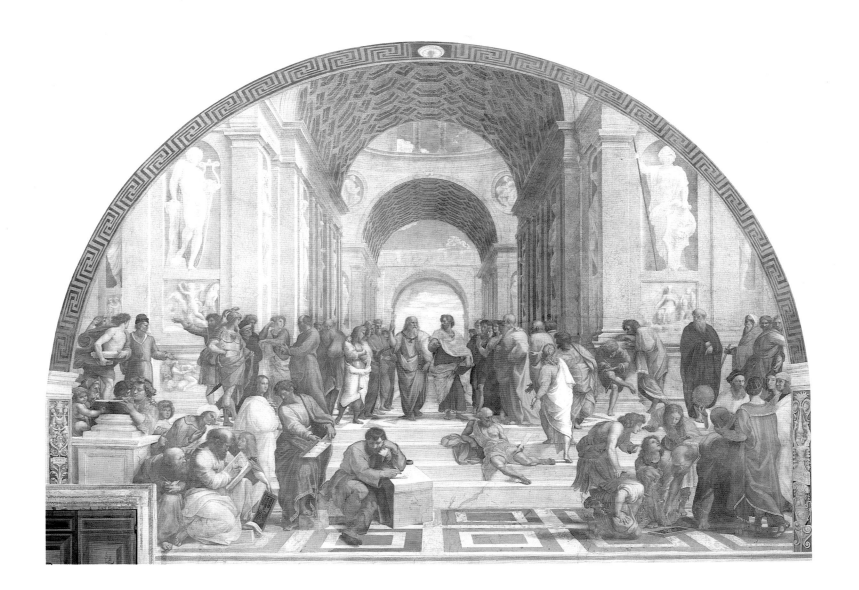

Plate 28. Cartoon for the *School of Athens*

29. School of Athens,
upper register

The mighty vaults of the architecture with their modulated surfaces recall both the ruins of the Basilica of Maxentius and the new St. Peter's, which Bramante was then constructing and which Raphael himself would have a share in supervising a few years later. The proportions of the structure in particular reflect the fully evolved confidence that he had achieved in these years shortly after 1508 in Rome. Indeed, we might even suggest that here after his Umbrian beginnings, and Florentine interlude, Raphael finally becomes Roman. Raphael provided ample space for monumental sculpture, and moving down the hall, which is conceived like a massive nave, we find sharply foreshortened niches with much-over-life-size statues in them, which utterly dominate in scale the living figures.

The nude marble rendering of Apollo, who is favored in the room since he appears on the ceiling and in the *Parnassus* as well as here, is overpowering. Yet, Raphael keeps him in check by giving him a background role. Matching Apollo on the opposite side of the hall is an analogous representation of Minerva the Italian goddess, who was identified with Athena of the Greeks. She has a military aspect, again a possible reference to Julius. Beneath Apollo are imitation Classical reliefs in a smaller scale, which confirm Raphael's devotion not only to Ancient subject matter and Ancient artistic representations, especially sculpture, but also to his skill in still life.

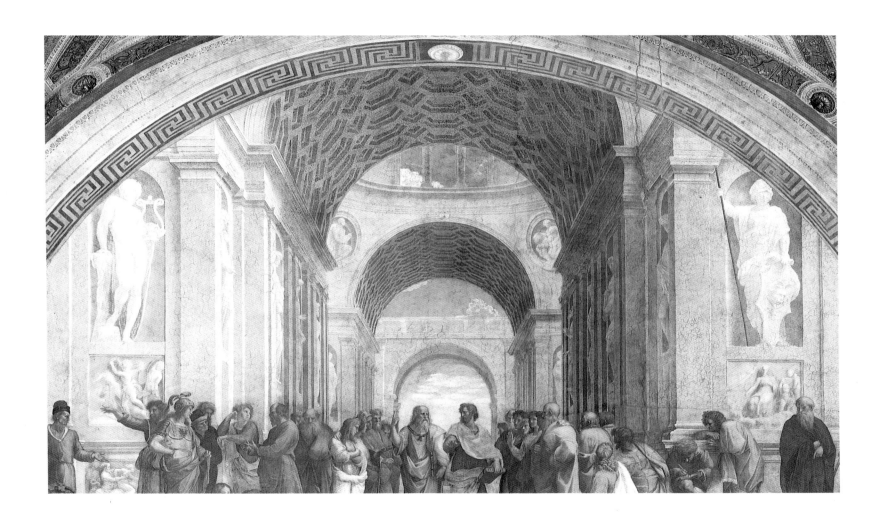

30. School of Athens, left side

In this portion of the *School of Athens,* we find that the figures are essentially arranged on a fairly shallow first plane established by the squared-off inlayed floor, whose perspectival orthagonals are constructed to bring attention to the central opening. The depth of this front shelf, or 'stage,' is delimited by the steps. Raphael had to contend with the actual door opening, which he incorporated into the composition as he had done elsewhere in the Segnatura. Here, on the extreme left, several figures congregate around a rather tall, squarish support, where there is a finely-wrought base but no column.

Ancient as well as modern identifications have been assigned to many of the figures in this fresco. The child looking directly out, to the right of the wreathed man in blue who leans on the support (Epicurus?), has been called Federigo Gonzaga of Mantua. The handsome, standing young man with the long flowing hair and dressed in an off-white garment is thought by some to be the Pope's relative and heir from Urbino, Francesco Maria della Rovere. Beneath him are the three principle figures of the section. The seated old man, Pythagoras, is deeply engaged in writing in a book, while a youth holds a tablet below. In the middle of this group is the standing man with his left foot raised on a stone block who has been variously identified (Parmenides?). The figure's contrapposto, with his left hip raised and right arm thrust across the body, is impressive. The seated, somewhat moody figure who leans on the desk, holding a writing instrument with his right hand, is usually referred to as Heraclitus. This heavy limbed, Michelangelesque philosopher from Ephesus was actually thought in earlier times to have been a portrait of Michelangelo. The pose and the way he supports his head with his left hand sets the mood for the contemplative quality of not only the thinker himself but the tone of much of the entire scene.

The color in the *School of Athens* is largely descriptive and tends to aid the legibility of the figures and the composition rather than take control of the viewer's attention for its own sake.

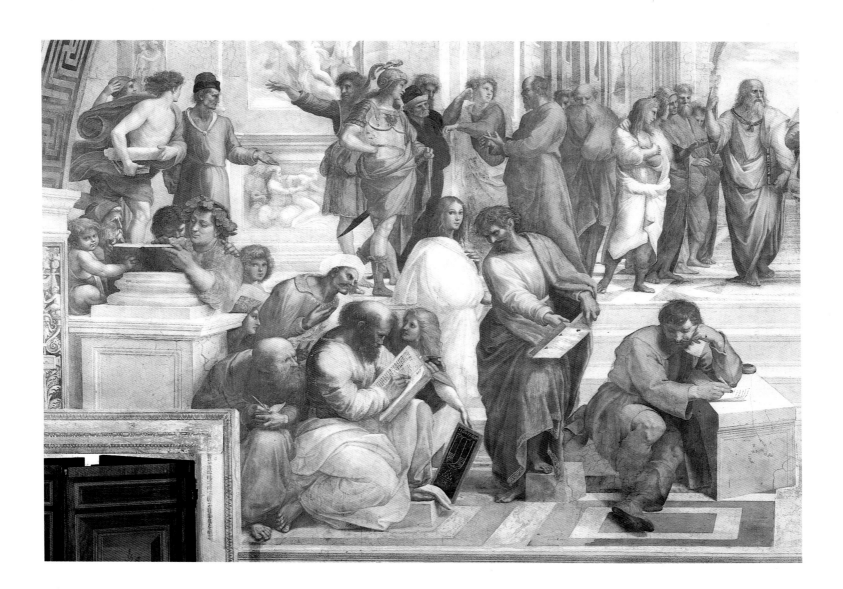

31. SCHOOL OF ATHENS, PLATO AND ARISTOTLE

The Greek philosopher Plato, who points upward, was thought to have been born on Apollo's birthday, May 21st. Hence his placement near to the statue of the god is appropriate. A pupil of Socrates, whose image is presumed to be found in the man next to him cn the left, Plato was in his turn Aristotle's teacher. It is said that he died at the age of 81, hence his presentation by Raphael as an old man. Since the facial type corresponds to a presumed self-portrait drawing of Leonardo da Vinci, many believe that such a reference was Raphael's intention. Aristotle, shown as a younger man, gestures earthward, while Plato points to the spiritual zones, as summations of their philosophical ideas. Aristotle was an exponent of the scientific method and emphasized experience in his philosophy, in opposition to the supersensual flavor of Plato's speculations. It can be argued that Raphael, somewhat miraculously, instilled these very qualities in his figural representations.

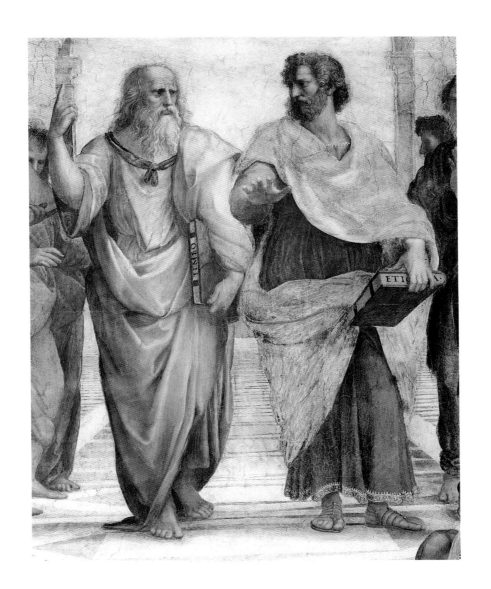

32. SCHOOL OF ATHENS,
LOWER RIGHT

The group of Ancients is compositionally centered around the bald head of Euclid, who intently draws on a slate with his right hand. The others, seemingly students, look on with diverse reactions to the demonstration. To the right of Euclid are two men facing each other; the crowned figure with his back to us is usually thought to represent the Alexandrian astronomer Ptolemy, who holds an earthly globe, while his opposite is probably meant to portray Zoroaster, whose globe contains the starry universe. The dignity of the personages, young, middle-aged, and old, is an important feature of Renaissance art in general, and Raphael's mode specifically.

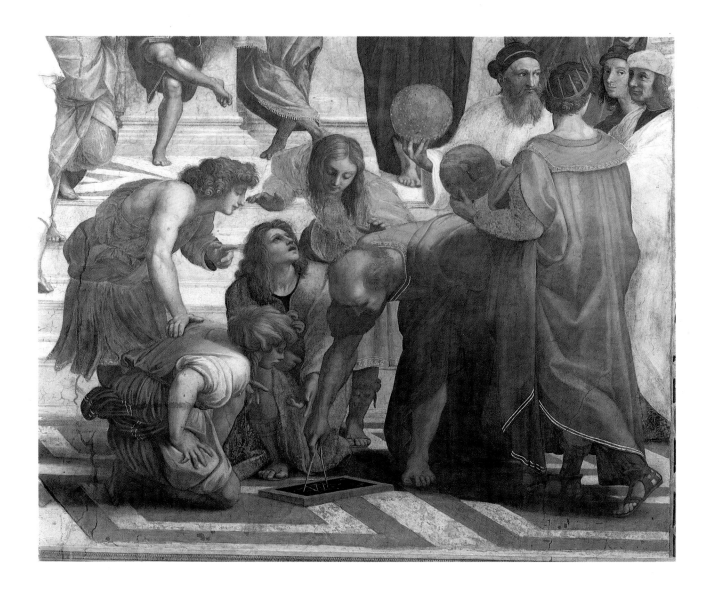

33. SCHOOL OF ATHENS, ZOROASTER, PTOLEMY, RAPHAEL, AND PERUGINO

As an afterthought, Raphael included himself looking out from the composition, as is often the case with such representations of painters in their narratives. We have some idea of his appearance from drawings and a (disputed) painting, but here the long-necked alert young man, not yet thirty years old, is shown clinically, without idealization. Next to him is probably a representation of his teacher Perugino, who was present in and around Rome during these years. The celebration of the two men is indicative of the new role that artists achieved in the Renaissance, moving beyond their older conditions as artisans to become prestigious members of the intellectual community.

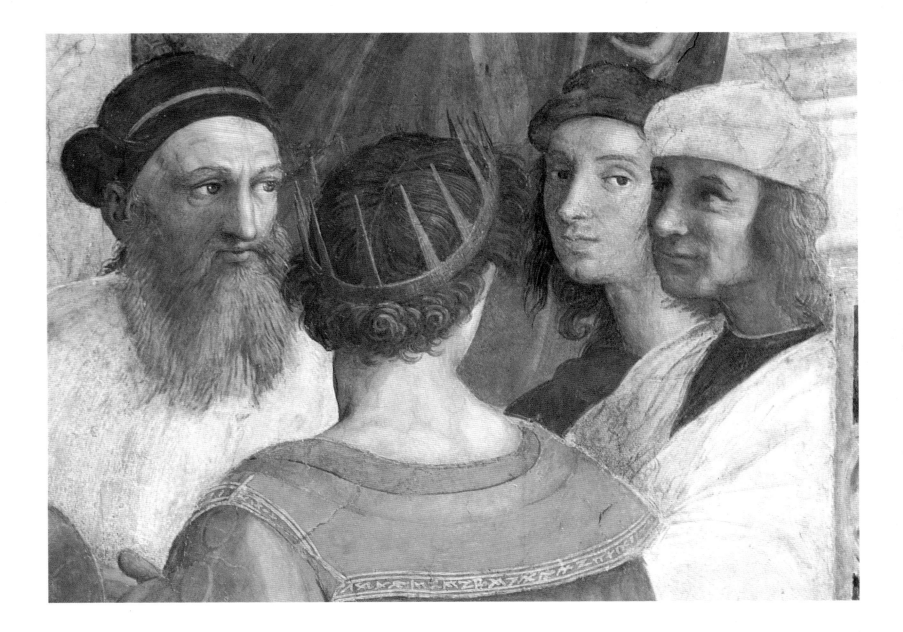

SELECTED BIBLIOGRAPHY

Beck, J.H. *Raphael*. New York, 1976.

Beck, J.H. *Renaissance Painting*. New York, 1981.

Bellori, G. B. *Descrizzione delle imagini dipinte da Raffaello d'Urbino*. Rome, 1695.

Beltrami, L. *Il cartone di Raffaello Sanzio*. Milan-Rome, 1920.

Camesasca, E. *All the Frescos of Raphael*. Part 1. New York, 1963.

Cavalcaselle, G. B. and J. A. Crowe. *Raphael. His Life and Works*. 2 vols. London, 1882.

Daubolt, G. "Triumphus Concordiae. A Study of Raphael's Camera della Segnatura," *Konsthistorisk Tidskrift*, 1975, pp. 70–84.

De Maio, R. "Savonarola, Oliviero Carafa, Tommaso De Vio e la Disputa di Raffaello," *Archivium Fratrum Praedicatorum*, 38, 1968, pp. 149ff.

De Maio, R. "Teologia e Reformatori nella 'Disputa' di Raffaello," *Riforme e miti nella Chiesa del Cinquecento*, Naples, 1973.

De Vecchi, P. *Raffaello. La Pittura*. Florence, 1981.

Dussler, L. *Raphael*. London, 1971.

Ettlinger, L. D. and H. *Raphael*. Oxford, 1987.

Fischel, O. "Due ritratti di Giulio II," *Bolletino d'arte*, 28, n. 1934, p. 195.

Fischel, O. *Raphael's Zeichnungen*. 8 vols. Berlin, 1913–42.

Fischel, O. "Due ritratti non riconosciuti di Giulio II," *L'Illustrazione Vaticana*, 7, n. 11, 1936, p. 514.

Frommel, C. and M. Winner, eds. *Raffaello a Roma. Il Convegno del 1983*. Rome, 1986.

Golzio, V. *Raffaello nei documenti, nelle testimonianza dei contemporanei e nella letteratura del suo secolo*. Vatican, 1936.

Gombrich, E. "Raphael's Stanza della Segnatura," *Studies in the Art of Renaissance*, London, 1972.

Gould, C. "Raphael's Portrait of Julius II: Problems of Versions and Variants; and a Goose that Turned into a Swan," *Apollo*, 9, (1970), pp. 187–89.

Gould, C. *Raphael's Portrait of Pope Julius II: The Re-emergence of the Original*. London, 1970.

Gutman, H. B. "Franciscan Interpretations of Raphael's School of Athens," *Archivium Franciscanum Historicum*, XXXIV, 1941, pp. 3–12.

Joannides, P. *The Drawings of Raphael*. Berkeley-Los Angeles, 1983.

Kelber, W. *Raphael von Urbino*. Stoccard, 1979.

Klaczko, J. *Rome in the Renaissance: Pontificate of Julius II*. New York, 1903.

Luzio, A. *Le lettere dantesche di Giulio II e di Bramante*. Genoa, 1928.

Mellini, G.-L. "Autoritratti, veri o presunti di Raffaello," in Sambucco Hamond, M. *Studi su Raffaello. Atti del congresso internationale di studi, Urbino-Firenze, 6–14 Aprile, 1984*. 2 vols. Urbino, 1987.

Messerer, W. "Eine Bildform in Raffaels Stanzen," *Festschrift Wolfgang Braunfels*. Tuebingen, 1977, pp. 247ff.

Nava Cellini, A. "Per il Poliziano nel 'Parnaso' di Raffaello," *Paragone*, n. 497 (1991), pp. 3–8.

O'Malley, J. "The Vatican Library and the School of Athens: A Text of Battista Casali, 1508," *The Journal of Medieval and Renaissance Studies*, 7 (1977), pp. 271–87.

Oberhuber, K. "Raphael and the State Portrait. I. The Portrait of Julius II," *Burlington Magazine,* 113 (1971), pp. 124–130.

Oberhuber, K. *Polaritat und Synthese in Raphaels 'Schule von Athen.'* Stuttgart, 1983.

Oberhuber, K. *Raffaello.* trans. M. Magrini. Milan, 1982.

Oberhuber, K. and L. Vitali. *Il Cartone per la Scuola d'Atene.* Milan, 1972.

Partridge, L. and Starn, R., *A Renaissance Likeness. Art and Culture in Raphael's Julius II.* Berkeley, Los Angeles, and London, 1980.

Passavant, J.-D. *Raphael d'Urbin et son Päere Giovanni Santi.* 2 vols. Paris, 1860.

Pastor, L. von. *Storia dei papi della fine del medio evo.* 10 vols. Rome, 1943–63.

Pezzini Bernini, G., S. Messari, S. Prosperi Valenti Rodino. *Raphael invenit. Stampe da Raffaello nelle collezioni dell' Istituto Nazionale per la Grafica.* Rome, 1985.

Pope-Hennessy, J. *Raphael.* New York, 1970.

Pouncey, P. and J. A. Gere. *Raphael and his Circle (Italian Drawings in the Department of Prints and Drawings in the British Museum).* 2 vols. London, 1962.

Quednau, R. "Raphael's Julius II," *Burlington Magazine*, Sept. 1981, pp. 551–53.

Rash Fabbri,. "A Note on the Stanza della Segnatura," *Gazette des Beaux-arts,* XCIV, 1979, pp. 97ff.

Schroeter, E. "Der Vatikan als Hügel Appollons und der Musen. Kunst und Panegyrik von Nikolaus V bis Julius II," *Rom Quartalschrift*, band 75, heft 3–4, 1980, pp. 208–40.

Salmi, M., ed. *The Complete Works of Raphael.* New York, 1969.

Shearman, J. "Raphael's Unexecuted Projects for the Stanze," in *Walter Friedlaender zum 90. Geburtstag.* Berlin, 1965, p. 158–80.

Shearman, J. *The Vatican Stanze. Functions and Decoration. Proceedings of the British Academy.* LVII, London, 1971.

Tolnay, C. de. "Un ritratto sconosciuto di Michelangelo dipinta da Raffaello," *Festschrift Friedrich Gerke.* Baden-Baden, 1962, pp. 167–72.

Vasari, G. Edited by G. Milanesi. *Le vite de' pió eccellenti pittori, scultori, ed architettori.* Florence, 1875–85.

Weiss, R. "The Medals of Pope Julius II (1503-1513)," *Journal of the Warburg and Courtauld Institutes,* 28, 1965, 163–82.

Wind, E. "Platonic Justice Designed by Raphael," *Journal of the Cortauld and Warburg Institutes,* I, 1937–38, pp. 69ff.

Wind, E. "The Four Elements in Raphael's Stanza della Segnatura," *Journal of the Courtauld and Warburg Institutes,* II, 1938–39, pp. 75ff.

Winternitz, E. "Archeologia musicale del rinascimento nel Parnaso di Raffaello," *Rendiconti della Pontificia Accademia Romana di Archeologia,* XXVII, 1952–54, pp. 359–88.

Zanghieri, G. "Il ritratto di Giulio II di Grottaferrata presumibile copia di un Raffaello perduto," *Capitolium,* 30, n. 7, 1955, pp. 209–14.

Zucker, M. "Raphael and the Beard of Julius II," *Art Bulletin,* 59, 1977, pp. 524–33.

GLOSSARY OF FRESCO TERMS

Affresco (in English usage, "fresco"). Painting with pigments dissolved in water on freshly laid plaster. As both plaster and paint dry, they become completely integrated. Known as the "true" fresco (or *buon* fresco), this technique was most popular from the late thirteenth to the mid-sixteenth centuries.

Arriccio. The prelim̶ ̶l̶ayer of plaster spread on the masonry. The sinopia is executed on ̶ ̶ ̶riccio was left rough so that the final, top layer (see *inton̶ ̶ ̶re to it.

Cartone (in Engl̶ ̶ ̶ ̶d̶rawing on paper or cloth of th̶ ̶ ̶ but not always, eq̶ ̶ ̶ ̶ ̶s̶ might be ̶ wall over̶ outlines artist i̶ The s̶

Giornata day an̶ his the̶ pai̶

**Intonac̶ made ̶

Mezzo fresco. Painting ̶ plaster less deeply than with ̶ ̶ tion is less extensive. *Mezzo* fresco w̶ teenth and later centuries.

Pontata. *Intonaco* spread in wide bands that correspond to succe̶ ̶ stages of the scaffold. The painter frequently laid some preparatory c̶ ̶ on these large surfaces as they were drying, but he usually spread his final colors after the *intonaco* had dried. This is largely, then, a *secco* technique.

Secco (literally, "dry"). Painting on plaster that has already dried. The colors are mixed with an adhesive or binder to attach them to the surface to be painted. The binding medium may be made from various substances, such as tempera. Tempera (the addition of egg yolk to pigments) was commonly used to complete a composition already painted in fresco. Because the pigment and the dry wall surface do not become thoroughly united, as they do in "true" fresco, *secco* mural paintings tend to deteriorate and flake off the walls more rapidly.

Sinopia. Originally a red ochre named after Sinope, a town on the Black Sea that was well known for its red pigments. In fresco technique the term is used for the final preparatory drawing on the *arriccio*, which was normally executed in red ochre.

Spolvero. An early method (see *cartone*) of transferring the artist's drawing onto the *intonaco*. After drawings as large as the frescoes were made on ̶ ̶ their outlines were pricked, and the paper was cut into pieces the ̶ ̶ ̶ ̶'s work. After the day's patch of *intonaco* was laid, the cor- ̶ ̶ ̶ placed over it and "dusted" with a cloth sack ̶ ̶ ̶hich passed through the tiny punctured ̶ ̶ll. This method was most popular in ̶ ury.

̶ sco painting from the wall by removing ̶ ̶Usually an animal glue is applied to the ̶ ̶layers of cloth (calico and canvas) are ̶ ̶ripped off the wall, pulling the fresco with ̶ ̶ry, where the excess plaster is scraped away ̶ ̶to its back. Finally, the cloths on the face of ̶ ̶oved. The fresco is then ready to be mounted

̶ ich a fresco is detached from a wall when the ̶ ainted has greatly deteriorated. *Strappo* takes off ̶ ̶th very small amounts of plaster. It is effected by ̶ ̶iderably stronger than that used in the *stacco* tech- ̶ ̶dure that follows is identical. After certain frescoes ̶ means of *strappo*, a colored imprint may still be seen on ̶ ̶ ̶aining on the wall. This is evidence of the depth to which the pig̶ ̶t penetrated the plaster. These traces of color are often removed by a second *strappo* operation on the same wall.

759.5 B393r 1993

Beck, James H.
 Raphael

759.5 B393r 1993

Beck, James H.
 Raphael

WITHDRAWN